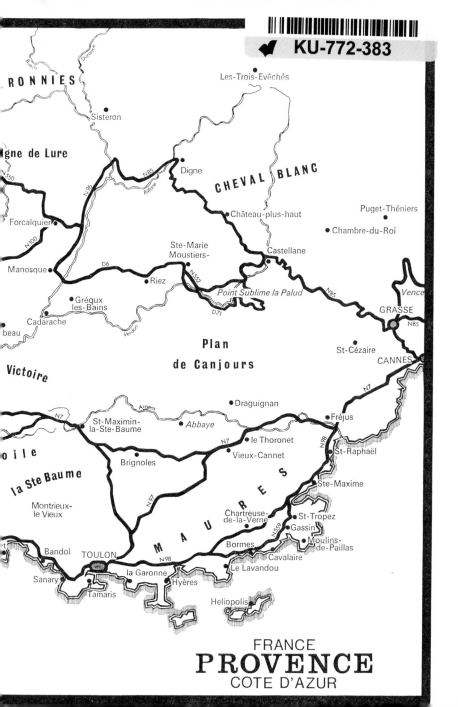

KU-772-383

RONNIES

Les-Trois-Evêchés

Sisteron

gne de Lure

Digne

CHEVAL BLANC

N 350

N 96

N 85

Bléone

Château-plus-haut

Puget-Théniers

Forcalquier

Chambre-du-Roi

N 100

Ste-Marie
Moustiers-

Castellane

Manosque

D 6

Riez

N 552

Point Sublime la Palud

Vence

D 71

GRASSE

N 85

Gréoux
les-Bains

Cadarache

beau

Verdon

St-Cézaire

CANNES

Victoire

Plan

de Canjours

N 7

Draguignan

Fréjus

N 7

Argens

St-Maximin-
la-Ste-Baume

Abbaye

N 7

le Thoronet

N 98

St-Raphaël

oile

Brignoles

Vieux-Cannet

la Ste Baume

Ste-Maxime

N 97

M A U R E S

Montrieux-
le Vieux

Chartreuse-
de-la-Verne

St-Tropez

N 559

Gassin

Bandol

TOULON

Bormes

Moulins-
de-Paillas

N 98

Cavalaire

Sanary

la Garonne

Le Lavandou

Tamaris

Hyères

Heliopolis

FRANCE
PROVENCE
COTE D'AZUR

PAINTERS' PROVENCE

★ ★

The author's previous works:

UNKNOWN IRELAND (Johnson)
UNKNOWN AUSTRIA: VOL I (Johnson)
UNKNOWN AUSTRIA: VOL II (Johnson)
UNKNOWN AUSTRIA: VOL III (Johnson)
A WINDOW ON GREECE (Heinemann)
GETTING TO KNOW PICTURES (Newnes)
PARIS TRIUMPHANT (Burke)
ROME RESPLENDENT (Burke)
LONDON MAJESTIC (Burke)
PAINTERS' PARIS (Johnson)

In collaboration with Eric Whelpton:

THE INTIMATE CHARM OF KENSINGTON (Nicholson & Watson)
CALABRIA (Hale)
SICILY, SARDINIA AND CORSICA (Hale)
GRAND TOUR OF ITALY (Hale)
GREECE AND THE ISLANDS (Hale)
SPRINGTIME AT ST HILAIRE (Museum Press)
SUMMER AT SAN MARTINO (Hutchinson)

BARBARA WHELPTON

PAINTERS' PROVENCE

★　★

JOHNSON

LONDON

BARBARA WHELPTON © 1970

First Published 1970

S.B.N. 85307 088 1

SET IN 11 ON 12 POINT BASKERVILLE, PRINTED AND MADE IN GREAT BRITAIN
BY CLARKE, DOBLE AND BRENDON LTD., PLYMOUTH
JOHNSON PUBLICATIONS LTD., 11/14 STANHOPE MEWS WEST, LONDON, S.W.7

CONTENTS

Chapter *Page*

I Introductory 7

II The Gateway to Provence 17

III Van Gogh Country 35

IV The Eastern Fringes of Provence 59

V The Lubéron, the Vaucluse and the Crau 73

VI From Martigues to Toulon 87

VII The City of Aix-en-Provence 99

VIII The Cézanne Country 113

IX Inland East of Aix 123

X The New Riviera and Picasso 131

XI Nice and the Painters' Villages 149

XII The County of Nice and the Route Napoleon 169

 Appendix 183

 Index 187

★ ★ ★ ★ ★ ★

I

INTRODUCTORY

PAINTERS' PROVENCE is a region which does not adhere strictly to the conventional boundaries. For it lunges out into the Languedoc, into the tiny duchy of Uzès, into the county of Nice and along the Côte d'Azur. It is a dramatic region where the black of cypresses and the silver of olive trees contrast with the deep, dusky red of the earth and where the brilliance of cornfields, shockingly golden yellow against the green-blue sky, inspired Van Gogh, where Cézanne struggled with the problems of relating colour and form and space, where Matisse worked and built a chapel, where Picasso painted vast wall decorations and designed jugs and dishes. Here too an entire museum has been built to house the works of Fernand Léger and a very modern assemblage of villas and terraces and galleries have been 'incorporated' into the hillside overlooking the Mediterranean to display contemporary works of sculpture and painting from all over the world.

It is not only the works of modern artists who have been inspired by the light and colour of Provence. In the fifteenth

century, the Bréa family created altarpieces of great beauty, glowing with a brilliant red, and the School of Avignon produced masterpieces in the same century, such as *The Burning Bush* in Aix Cathedral and *The Coronation of the Virgin* at Villeneuve-lès-Avignon. Ruined temples and well-preserved theatres, medieval monasteries, churches and cathedrals bear witness to the number of artists who have been born here or who have come here and produced splendid works of art under the southern sun.

I find it better to plunge right into this wonderful region of Provence rather than to come upon it driving gradually southwards. To leave Boulogne when darkness falls and then to awake in the early morning to an entirely new world is a wonderful experience. I am always excited by the red tiled roofs of the long low houses, the lines of cypresses, the windbreaks of regimented trees, softened perhaps by a little mist before the sun comes blazing down from a deep blue sky to intensify the colour for a while before draining it away in the mid-day light.

Then for a day I like to forget about the museums and monuments of Avignon and escape deep into the countryside before the traffic is moving and whilst there is a feeling of expectancy in the air and everything is emphasised by its contrast with the world of the previous evening.

This is a country that is an essential part of France and yet not altogether France. Provence is a Mediterranean land, Mediterranean geographically in climate and in scenery. The Phoenicians came to Arles and to Marseilles to trade; the Greeks had their factories in Marseilles and near Cannes. The Romans conquered Provence before the rest of Gaul and made it their own land where veteran soldiers could retire to plant olive trees and vines. They built cities as large as any in Italy save only Rome and Milan. So at Nîmes and at Arles and at Orange there are theatres and amphitheatres, temples and cemeteries. The link with Greece was tenuous but the Maison

Carrée at Nîmes, though built by the Romans, is in the hellenic tradition, and so too are some of the statues, discovered in the Provençal soil and now in the museums. Perhaps it may seem pedantic to refer to antiquity when writing about the country-side which has inspired Matisse, Picasso and a large number of young artists. One may well ask what relationship scenery and classical buildings can have with painters who have abandoned all pretence of representational art. The answer is I think, that Provence like Paris has the aura of creativeness—a creativeness that has endured through thirty centuries and more. The Vallée des Merveilles, north-east of Nice, has graffiti of the Bronze or Iron age decorating its slabs of greenish rock.

In this country the past and the present provide constant surprises, for new or forgotten interpretations of art are constantly making their appearance. When Picasso launched his pottery industry at Vallauris, he was, after all, only practising a craft that is as ancient as any of the Mediterranean civilisations.

The Mediterranean landscape is never romantic in the sense that the landscape of southern England or of parts of the north of France are romantic. At its best, Mediterranean scenery always requires completion by the hand of man. Without human agency we should have nothing but scrub and rock and bleak mountains. The olive, the vine, the terraced land, the carob and the disposition of the farm houses and the peasants' cottages in their cubic patterns are there by man's agency though, admittedly, the form of the buildings is stressed by the bright sunlight. The horizontal lines of the red roofs break the hard outlines of the very vertical cypresses and the softly shimmering olives reflect the light in a kind of radiance, a light which is more brilliant, more golden than the subtle silver of the Ile de France, but a light which inspired Van Gogh's blazing golden cornfields and took him far from the dour darkness of his native Holland.

You may ask, who were these people who, like the Italians,

Avignon from Villeneuve

did so much to create the loveliness of their own scenery? First of all perhaps the Greeks, the Phoenicians and even the Etruscans in the east of Provence. Then came the Romans who brought the best and perhaps the worst of their civilisation to this part of France which was densely populated during their empire. When the Franks invaded Gaul, Provence remained essentially Roman, though it was occupied like the rest of the country. The Romans bequeathed to it their language, their customs, and their traditions. When Charlemagne's immense empire disintegrated, there emerged a kingdom of Arles which comprised at its greatest, Provence, Burgundy and the whole of the territory bounded by the Alps, the Mediterranean and the Rhône. Later we find a county of Provence extending from the eastern shores of the banks of the Rhône to the Alps with the Count owing allegiance to the Holy Roman Emperors, whilst to the west of the Rhône was the County of Toulouse which was nominally a fief of the Kings of France. So it was that, until the fifteenth century, the subjects of the king and the subjects of the emperor faced each other across the river and built fortifications to defend themselves from attack by people who were, after all, of the same race. So for instance, at Tarascon the Castle of King René of Provence faces the Castle of the Counts of Toulouse at Beaucaire. The Palace of the Popes at Avignon looks across the Rhône at the magnificent castle of Villeneuve-lès-Avignon which was part of Avignon although it was on the wrong side of the river. Until quite recent times, boatmen as they veered their craft from one side of the Rhône to the other, would shout 'Empire' or 'Royaume' according to whether they swerved to the right bank or to the left.

In the early thirteenth century, a Pope launched a crusade again the Albigenses, a heretical sect which flourished mainly in the county of Toulouse, but also in some cities of Provence. A glorious civilisation was extinguished after massacres and

plundering by the troops of Simon de Montfort, a Frenchman whose son was destined to figure in the history of England. Some of the lands of the victims were seized and the Pope received as his share of the booty the city of Avignon and the land surrounding it known as the Comtat Venaissin, which includes among its lovely towns, Orange, Avignon, Cavaillon, Apt and Carpentras. Later the pontiffs also acquired the whole of the Vaucluse which still possesses a definite character of its own, the rich and well irrigated soil of the most southerly valley of the Rhône making it produce vegetables and fruit in abundance. At the Fontaine de Vaucluse, the subterannean river bursts out in torrents fed by the waters from Mont Ventoux to the north.

The lovely Abbey of Sénanque stands almost in the centre of the plain and, to the east, the picturesque little town of Ile sur la Sorgue.

Under pressure from the kings of France and owing to the anarchy that prevailed in Rome, the seat of the Papacy was transferred to the Comtat at the beginning of the thirteenth century, and later to Avignon which the Pope bought from a Countess of Provence in 1348. One way and another the Popes remained in Avignon until 1403, but the city was part of the papal territories until the French Revolution.

During the years of papal residence, art flourished in the south and there were many painters and poets at the Papal Court. These men were not French; they were for the most part brought from Italy, in particular the Sienese who decorated the Palace of the Popes. They may well have enlisted the help of French artists and it is certain that they had a great influence on early French painting. Those men who are usually referred to as French primitives are then mainly foreigners who were in the service of the Pope or of wealthy French patrons and, although a large number were Italians, Spaniards and Germans are known to have been painting in the south

and a large number of Flemish were working in Burgundy in the fifteenth century.

It is probable though, that Frenchmen were responsible for the eleventh, twelfth and thirteenth-century frescoes still to be found in a rather dilapidated condition in churches all over France and these, as far as can be seen, follow the style of the miniatures and stained glass of the period. Despite the splendid achievements of the medieval French in building the

magnificent Gothic cathedrals, there was a period of stagnation all over the country during the Hundred Years War when very little was produced. Then, in the south, came the years of papal and royal patronage of artists brought in from abroad and from other regions of France. There were, however, some exceptions to the rule of Italian artists at the Palace of the Popes, for it is almost certain that the elegant tapestry-like decorations in the Garderobe were French as they are reminiscent of the illustrations to Books of Hours and in this field the French influenced the Italians rather than the Italians the French.

Since we are only concerned with painting in the south of France, there is no occasion to go into the early history of French painting as a whole and we must confine ourselves to the School of Avignon and the School of Nice with a few minor offshoots.

In both cases the term 'school' is a loose one for it does not refer either to painters of one nationality or region of birth nor to those working in the same tradition, but to a collection of artists from different countries and different provinces of France painting in or near the same centre. The main artists of interest are firstly, Enguerrand Quarton (sometimes called Charonton) who came from Burgundy and was commissioned by a priest of the Hospice at Villeneuve-lès-Avignon to paint the *Coronation of the Virgin* which still hangs there, and secondly the unknown genius who painted the much more powerful, sombre Pietà for the same hospice (this latter is now in the Louvre—a dull copy hangs in its place). Thirdly Nicolas Froment, born at Uzès, who produced the altarpiece of the *Burning Bush* in the cathedral at Aix, for King René of Provence.

As might be expected, the School of Nice is almost entirely Italianate with a slight touch of Spanish heaviness of colour, and its leader was Louis Bréa who did indeed work in Italy and founded a school at Genoa. In Nice and in churches in other towns in the area there are several altarpieces by this artist whose works, according to an early nineteenth-century dictionary of painters, 'are well composed for the time and his figures tolerably drawn and gracefully turned'.

The truly French school which flourished in the sixteenth century in Touraine, where Jean Fouquet was court painter to Charles VII, is outside the scope of this book.

During succeeding centuries, isolated painters came to work in Provence, but it was not until Corot and then the Impressionists found inspiration in the landscape that a flow of artists comparable to the influx in papal times came, not only

from other regions of France, but from all over Europe to settle in increasing numbers. I doubt if there is any provincial region in any other country in Europe where in recent years so many artists have been working at the same time.

II

THE GATEWAY TO PROVENCE

Pont-St-Esprit – Orange – Vaison-la-Romaine –
Carpentras – Avignon – Villeneuve–lès-Avignon

HALF a century ago, it was still possible to go down the valley of the Rhône and enjoy the scenery and the monuments *en route*, but now the countryside near the main highways has been spoilt and so it is preferable to go by secondary roads. Before the advent of the railways, travellers used to go from Lyons to Marseilles by boat which must have been an entrancing experience; indeed, diarists of that time considered the landscape to be as fascinating as that of the Rhine valley. If you wish to avoid the Rhône valley, you can follow the course of the Ardèche as it meanders across the plain. In this region the sun gradually begins to feel warmer as the impact of the south makes itself felt, after the more bracing northerly regions. The cottages and farms are washed in pink, blue and white and, in the clear atmosphere, everything seems to take on a different aspect; even the distant hills and mountains change from brown or grey to deep blue or

purple and the fields and the trees radiate the brilliant light. Here, of course there is both southern and northern vegetation in charming confusion and the typical Provençal olives and cypresses are not yet much in evidence.

Near Pont St Esprit, the Rhône is reached once more—the swirling waters now under control by the immense hydro-electric works which have successfully canalised the broad spreading river. In some ways this has perhaps spoiled the landscape, for it has changed its aspect. On the other hand, the engineering work has been carried out with great respect for line and proportion and there is something rather splendid about this great expanse of water being held in check by slop-ing concrete banks and dams. It was the monks of the Papal Court of Avignon who built the long bridge across the river at Pont Esprit; it originally had twenty-five arches but only nineteen now remain.

The huge fifteenth-century church of St Saturnin itself rises up from the ancient houses lapped by the Rhône, one or two of which are also fifteenth-century, and, from a broad terrace, one can look across to Mont Ventoux which rises nearly 6,000 feet above the sea, its peak covered with snow in winter.

Though Pont St Esprit is a pleasant enough town and is rightfully claimed to be the gateway to Provence, Orange is a much more dramatic entrance. It is not far away and there is nothing to induce one to linger on the busy highway which links the two cities.

What a magnificent entry this is, with the huge Roman triumphal arch probably erected in the year 49 B.C. Its excel-lent state of preservation makes this whole massive structure even more impressive with its central arch and two smaller flanking ones. Corinthian pillars on either side of the arches support the huge superstructure which is covered with reliefs of Caesar's legionaries battling victoriously against the Gauls and the Roman Navy defeating the Greeks. Admittedly some

of these carvings have been damaged or effaced, but this does not spoil the general effect of the monument against a background of trees in the public gardens.

The Roman theatre is also in a good state of preservation and is the only one in Europe with its façade still intact, but some of the tiers of the auditorium had to be skilfully restored in the last century, since it is still used to present classical plays in the summer. Unfortunately the stone from the Roman temples and baths was taken away to build the castle on the hill early in the seventeenth century, so the greater part has disappeared, but the arch and the façade of the theatre owe their preservation to the fact that they were incorporated into the fortifications.

The small lapidary museum in the square contains Roman relics of interest to the classical scholar; some portraits and a collection of paintings by Brangwyn. I have no idea why this Englishman's paintings are here.

Orange, which was obviously of such great importance in Roman times, has now dwindled to a little town of about 20,000 inhabitants with narrow streets, lined with colour-washed houses, and some small attractive squares shaded by lime trees.

It is not far from Orange to Avignon by the direct route, but it is well worth taking a long deviation to visit Vaison-la-Romaine which is one of the most interesting and beautiful little towns in the south of France. The road runs through delightful pastoral country and, on the horizon, the huge mass of Mont Ventoux is silhouetted against the sky. A few miles from Orange lies the fascinating fortified town of Camaret, approached by an avenue of limes, encircling a complete ringed rampart with large gates and flanking towers. It has the aspect of one of the towns in a Book of Hours, set as it is in the midst of open countryside.

The magical sight of this city was one of the highlights of driving through this lovely patch of country before arriving

at Vaison just as the sun was setting. We chose a hotel in the market place so that we could dine on the terrace and watch the life of the town.

Vaison-la-Romaine really consists of two towns, the lower and older on the plain, and the upper on the slopes of a steep hill on the side of a torrential stream. It has a most dramatic effect, perched on the rather jagged rocks, with a square castle keep that once belonged to the Counts of Toulouse crowning the slope. The lower town may have been an outlying settlement of the Greek colony at Marseilles, but it was certainly occupied by the Romans for many centuries and prospered as a city of importance until it was over-run by the Barbarians. Nevertheless it became a see in the third century and the Bishop resided there throughout the Dark Ages. The town had a second period under the Counts of Toulouse who built the medieval city on the slopes in the eleventh century. Decay set in when the railways were built, but the town regained its importance when nineteenth-century archaeologists rediscovered the Roman ruins which have given great cultural importance to the city and now attract large numbers of visitors.

Today the upper town has a colony of artists and writers who have restored and redecorated many of the old houses and brought life to the cafés of the market square.

Except for the specialist, Roman ruins can often be very tedious, especially if they are scant vestiges, but those at Vaison form part of a really lovely landscape and are visually most satisfying, even if you do not want to examine them too closely or bother with such details as to which of the rows of broken columns and stonework constituted the main street or the forum. The theatre lacks the feeling of vast emptiness of the one at Orange, since it is on a much smaller scale, but it is a good focal point in the landscape because it is set on the slope of a small low hill facing the open country of fields and orchards which stretches at the foot of a dramatic sweep of

mountains. The topmost tier of the auditorium is enlivened by a line of broken columns of different heights which shine pale against a background of dark green foliage. On the southern slopes of the same hill, the masonry and pillars of the Roman town are saved from monotony by lawns and rows of cypresses and flower beds. Good casts of some of the best of the statues which were found there have been carefully placed to lend even more interest to the ruins. There is a further portion of the Roman town which has been excavated lower down the slope, but it is like many other Roman ruins that can be seen all over France.

In contrast to the Roman remains, stands the superb little cathedral, the beauty and simplicity of its lines emphasised by the background of wooded hills. It was originally built in the sixth or seventh century A.D., restored in the eleventh century and enlarged some years later. Many of the early features are embodied in the new structure, but, as it was built with material from Roman times, it has the appearance of a classical building for it is circular and the roof is supported on columns. It is just conceivable that the stone Bishop's throne is the one that was in use from the third century.

The cloisters were built partly in the first half of the eleventh century and partly during the twelfth century, but a great deal of restoration was carried out in the nineteenth century to the vaulting and to the carved capitals so that it is the general effect and proportion that is interesting, and the cloisters certainly make a fitting background to the growing collection of Christian art which is displayed there. There is a very interesting fifth or sixth-century marble sarcophagus carved with the apostles acclaiming Christ Triumphant; and a number of Merovingian and Carolingian carvings of interlacing and geometric patterns.

The medieval town is a short walk away over the graceful Roman bridge across the torrent, and a narrow cobbled street follows part of the old ramparts to pass beneath the gateway

formed by the tall belfry. It leads into the attractive market square with its stone fountain and huge plane trees. This affords a good starting place for exploring the old streets, where there is plenty of interest to occupy a half-hour's stroll. A Gothic gateway leads into the former ghetto; the mansion which once belonged to the family of Simon de Montfort is still intact, as well as the Old Bishop's palace and a number of mansions of different periods. The architecture of the whole medieval town has a definitely Italian character which is not surprising since Vaison was included in the Papal territory of Avignon until the end of the eighteenth century.

The climb up to the castle is steep and the ruins themselves offer no reward since only an empty shell is left, but the view is really a lovely one, reaching to the distant towers of Orange whilst the varied red hues of the roofs of the medieval town descend in tiers to the river gorge. Eastwards the purple ranges of the Alps are tipped with snow; between them and the town stretches the patchwork of the plain with its pale green fields, dark woods, and the silvery foliage of the olives.

From this height there is a foretaste of the countryside through which one passes to reach Carpentras. It is even more lovely at close quarters, especially in the spring when the meadows are white with narcissi and the gardens full of lilac. Dark cypresses frame small villages or else are strung out in long processional lines. At Malaucène a road climbs up the slopes of Mont Ventoux from which, on a clear day, there is a view which includes the Alpine range for nearly a hundred miles. There is an hotel half way up and I believe that there is a chalet at the top which is open in the summer for refreshments.

We have always found Carpentras utterly enchanting, with its narrow streets of warm yellow houses, and its little square where the cheerful friendly population bargain over the produce on the stalls; it has a breath of the South, and is typically Provençal for unlike the larger towns in the region, it has not

suffered the over-commercialisation which is so apt to swamp regional character.

The fifteenth-century cathedral of St Siffrein has a few mediocre paintings but also a most interesting fifteenth-century picture of a *Virgin with Saints*. The ruins of the former Romanesque cathedral can still be seen near the apse, with its beautiful cupola and rich decorations.

Perhaps even more interesting than the fifteenth-century cathedral is the early eighteenth-century synagogue, a reconstruction of the fifteenth-century edifice which is, I am told, the oldest in France. In the courtyard of the seventeenth-century lawcourts, there stands a well-preserved Roman triumphal arch with reliefs showing captive Gauls.

The Musée Contadin is mainly of regional interest, including some primitive paintings and there is also the well-arranged archaeological museum. The Musée Sobirats has its first floor arranged as a dwelling house with furniture and tapestries and the second floor is given over to religious art. The eighteenth-century Hôtel-Dieu is certainly worth a visit with its Gobelins tapestries; its pharmacy with amusingly painted cupboards has a remarkable collection of Moustiers porcelain. There is a particularly lovely fireplace and a grand staircase with delicate wrought iron.

Carpentras is not far from Avignon, in fact it is about the same distance as it is from Orange, so of course it is perfectly easy to go to Avignon from the former city and get a first view of it from the opposite side of the Rhône from Villeneuve-lès-Avignon. The terrace there gives a most romantic view of the town and the Palace of the Popes.

It is also from Villeneuve that the best view of the old bridge—the famous Pont d'Avignon—can be seen. It was built in 1180 by monks and, according to legend, a young shepherd named Bénézet saw the bridge in a dream when he heard voices urging him to build it. He was much ridiculed for this suggestion and was ordered to lift up a huge stone,

13 feet long and 7 feet wide, to test his integrity. Needless to say, the shepherd raised the burden with ease and then carried it to the banks of the Rhône as a foundation for the bridge.

There were originally nineteen arches, but all except four were swept away by floods. On the second tier of the bridge a chapel was erected in the twelfth century in honour of the newly canonised Bénézet. One of the explanations of the well-known nursery rhyme is that since the streets of Avignon were narrow, and there was very little space for gatherings of any kind, the people danced on what was left of their bridge.

The immense Palace built by four of the French popes is more of a fortress than a palace, its huge battlemented walls rising up from the surrounding buildings and dominating the whole of the town. The long perpendicular lines of the buttresses make a lovely contrast to the horizontal lines of the soft red roof tops and the flow of the silvery water. The grey-green shimmering leaves of the olives on the slopes above the river are pierced here and there by the decisive dark shapes of groups of cypresses.

Since most of the skill of the fourteenth-century architects responsible for the palace went into making an impregnable fortification, the building is more impressive than beautiful. It does, in fact, consist of two palaces; the old palace built by Benedict II who pulled down what had already been constructed, and the new palace built for Clement VI during the middle of the fourteenth century and added to by Urban V in 1364. Both the exterior and interior of the earlier portion is much simpler and more austere than the later portion, which was splendidly decorated by Clement VI. It was badly damaged during the Revolution; the sculpture was battered, the frescoes were slashed and the whole place was despoiled. It even served as a barracks in the early 19th century, but restoration carried out in the present century has restored it to the state it was in before the Army took it over, but this is a rather bare and empty state.

The Palace is an exceedingly tiring place to visit, for it covers an enormous area and it is necessary to walk along a maze of narrow passages and climb endless stairways with little chance of omitting anything since all visits are accompanied. However the great hall, with its huge ceiling supported by pillars, is a splendid example of medieval architecture. The very high walls look especially lofty now they are shorn of the carvings which broke their austerity and the tapestries which gave them warmth, for very little remains of the once splendid decorations carried out by picked artists from all over Europe. It is possible though, to discern a few figures of prophets on the ceiling which were originally painted against a brilliant blue ground decorated with stars. The remains of remarkable frescoes by Sienese artists can still be seen in the two chapels of St Martial and St John. In particular in the chapel of St Martial there is a vivid interpretation of the resurrection of a dead man. The dignified saint in a robe decorated with stars, gives a blessing with one hand as he gently clasps the hand of the man who is gradually coming to life with a mystified look on his face. Another shows the destruction of an idol whilst pagan priests are being converted. Two exquisitely beautiful figures are those of Christ and the Virgin who stand affectionately welcoming the soul of St Martial after he is borne aloft by angels. In the Pope's private apartments, in the wardrobe tower, the frescoes are in a good state of preservation. Here the walls have been decorated with scenes of country life and are designed continuously from room to room. These paintings are almost certainly by Frenchmen and they have all the delicacy and elegance of French art, strongly influenced by illuminated manuscripts and with some of the enchanting background patterning of early tapestries. In all the overwhelming power and austerity of this vast fortification, this is the one room in which it is possible to recapture the delight of the artists working on the decorations, creating a paradise of woods and meadows. Flowers grow everywhere and all kinds

of foliage are traced against the sky and the hillside, whilst wild animals peer through the undergrowth and fashionably-dressed, slender figures carry out their pursuits of hunting and fishing in the foreground. Quite apart from the style it seems obvious, surely, that only native artists could recreate the French countryside with such sympathy.

The Cathedral of Notre Dame des Doms stands next to the Palace of the Popes and is distinguished by the hideous over-sized gilt statue of the Virgin set up on the balcony in the nineteenth century. The main part of the church is twelfth century but has been so much restored and altered that it is scarcely recognisable as such, and none of the tombs of 157 cardinals, archbishops and bishops remain, but the splendid Gothic sepulchre of John XX, the second Pope of Avignon, is in a closed chapel. The beautiful white marble archbishop's throne which stands at the entrance to the choir, on the left, was carved in the twelfth century. On the Rocher des Doms, just behind the cathedral, a charming public garden gives views over the town towards Mont Ventoux and across the river to Villeneuve.

There are a number of churches of interest, built between the fourteenth and sixteenth centuries. St Peter's has some particularly good, delicately carved Renaissance panels in the main door which is protected by shutters, and there are also wood carvings in the choir. The first chapel has a Renaissance mausoleum and the pulpit is the work of a fifteenth-century sculptor. There is a superb view of the town and the palace from the platform of the bell tower.

The church of St Didier, built in the fourteenth century, contains a remarkable altarpiece carved by a Dalmatian sculptor, Francesco Laurana, who was working in the latter half of the fifteenth century. Although he was born in Dalmatia, he was Venetian and he worked a great deal in Sicily and France. This altarpiece is often referred to as the altarpiece of Our Lady of Spasms on account of the exaggerated expression of

grief and horror for which this artist is renowned. He has been so completely successful that it seems quite unnecessary to describe the subject of the picture in the eleven Latin verses which are written below.

The fourteenth-century church of St Agricola was partly rebuilt by John XXII and was again altered and enlarged at the end of the fifteenth century. The entrance portal still keeps its Gothic doorway and part of a graceful Annunciation group by a late fifteenth-century sculptor.

In complete contrast to this church, the seventeenth-century Chapel of the Black Penitents is most elaborate in style with a huge decoration on its façade representing two angels carrying the head of John the Baptist on a plate. Even more violently contrasted is a remarkable modern church which has recently been completed in the little visited quarter of Avignon by the Palais de la Foire.

The Musée Calvet was founded in the early nineteenth century from the collection left by Esprit Calvet—a doctor and archaeologist who died in 1910. This was added to the Municipal collections and exhibited from 1833 onwards in the Hôtel de Villeneuve-Martignan which was the largest and most beautiful of the eighteenth-century mansions of Avignon. The house itself still keeps its eighteenth-century character and the garden is an enchanting one to sit in, with its large shady, rather forlorn looking trees, its smooth lawns and the brilliant peacocks which strut about in numbers, adding their glittering blue-green to the pale green grass. The collections are among some of the most important paintings and carvings of provincial France and include Primitives of the School of Avignon of the fifteenth century and a number of works from the seventeenth, eighteenth and nineteenth centuries as well as contemporary works. There are also galleries of prehistoric finds and of the art of Egypt, Greece and Rome, with a large collection of wrought iron which is world famous and well worth visiting although only part of it is on show.

The School of Avignon is extremely well-represented and can be studied in this museum better than anywhere else. Amongst them is a St Lawrence and also some semi-heraldic panels from a Gothic house in Avignon by an anonymous painter, and some very attractive panels of heads against a lovely pale red background. *The Adoration of the Child*, also ascribed to the fifteenth century, by its sophistication seems later to me. The painting of the brocade robes is particularly accomplished.

One of the most impressive works by this school is a panel from the altarpiece of Venasque with deep, glowing red robes, a gold background and an elaborate golden Gothic framework complete with alcoves and medallions. In the painting of *St Catherine*, the glorious red is still used against a gold background and the painter seems to have become entirely fascinated with the brocade mantle of black and gold over a white robe. An amusing note is added by a figure which may be the Emperor Maxentius, the saint's unsuccessful suitor, trying to force his way from beneath the ground, but being held back by St Catherine's sword.

A fifteenth-century *Resurrection* from Westphalia has a subtle harmony of colours: oranges, pinks and greens, and a wonderful red robe for Christ, as soft and gleaming as velvet. The landscape background, reminiscent of the Flemish school and of the background of illuminated manuscripts, is set against a clear sky with a sensitively observed sunrise. The tomb, out of which Christ is stepping, is placed at an unusual angle obliquely across the panel, but it is balanced by the expert grouping of the half-sleeping figures at its base.

Of the new acquisitions to the gallery, there is a wonderful addition to the School of Avignon, the *Martyrdom of St Sebastian* which is exceptionally good in colour. There are also a number of works in this section of modern local artists of quality, but mainly unknown to me.

A number of huge, rather overwhelming and gloomy paint-

ings by Hubert Robert, whose smaller pictures are so lovely, and some by Panini and other rather overwhelming landscapes of this type fill several rooms. Their size, the monotony of the scenes and the dark brown varnish make this section rather depressing. There are a number of Dutch paintings and some Flemish, but the *Kermesse* is only an ancient copy of the original by Peter Breughel the Elder. In the upper rooms there are some very 'modern', contemporary works and also a

number of Impressionists and paintings of the School of Paris. I found an early Sisley of the *Lapin Agile in Montmartre* and another of the *Square of St Pierre*, and there are some very beautiful Seurat drawings and some Segonzac's in the deep browns and purples he so favours; a lively sketch by Toulouse-Lautrec, some works of Utrillo, Vlaminck, Vuillard and Marie Laurencin complete this remarkable collection.

The prehistoric section has a few rooms of neolithic flints and bones and items which I always find rather boring, but the end cases have some intensely interesting *stele*, of the second half of the third millenium, from the Vaucluse. These are wedge-shaped and have the simple primitive features of a

head; raised circles for the eyes, a straight ridge for the nose and a decorative treatment of what may be intended to give the effect of a large head of hair; but of all the prehistoric exhibits, the one I found the most interesting was the slab of greenish rock from the Vallée des Merveilles engraved with figures and strange signs and entitled '*Le Chef de Tribu*'. This is, admittedly, not of very great artistic value; there is little vitality and still less sense of design, but it impresses by its great antiquity and it comes from Tende in the Alpes Maritimes, north of Nice, a region which I shall describe in a later chapter, where you can climb about on the rocks and find many more such engravings.

The Musée Lapidaire is very small compared with the Calvet. It is housed in a former seventeenth-century Jesuit chapel and is, at first sight, a little dreary, doubtless because of the lack of a suitable background to show up the colours of the stone, but it is in fact an extremely interesting collection with some very beautiful Roman, Early Christian and medieval carvings. Each of the side chapels of the former church have some wonderful fragments of carvings grouped together. For instance, there is a Christian altar of the sixth or seventh century, consisting of a marble slab where only the thickness is decorated with a simple pattern, whilst others have the Early Christian fish symbol. The Byzantine capitals are carved with the usual intricacy of this style, and there are several most interesting sarcophagi, more especially the one with a panel entitled *Halage*. In this there are men in a boat containing a number of barrels, and other men realistically heaving it along with ropes. Another depicts a Roman stage coach with heavily built horses with heads rather like large cats. This last one comes from a castle at Vaison-la-Romaine and is similar to the one at Maria Saal in the Carinthian province of Austria.

Do not miss the *Lion* of Noves and the *Venus* of Pourrier, the medieval marble statues in the chapel to the left of the sanctuary, nor the remarkable carved and painted figures,

especially the Pietà. This is most expressive and still keeps a certain amount of the original colour. A most entertaining Romanesque capital depicts Job very realistically plagued with boils and pathetically resting his anguished face on an emaciated hand.

There is a splendid recumbent statue of Pope Urban V from the chapel of St Martial described earlier.

After the traffic of Avignon, it is a relief to cross the Rhône to Villeneuve-lès-Avignon which is quiet and peaceful, albeit a trifle dull. The entrance from Avignon is close to the Tower of Philippe-le-Bel which was part of a castle built in the thirteenth century to defend the St Bénézet Bridge. There is a lovely view from the second storey which was added in the fourteenth century. As I said earlier, the best view of the Palace of the Popes and the bridge is to be had from the Terrace up at Fort St André, the great stronghold which dominates the town. It is a view which was painted by Corot and by many others before and since his time.

The Fort itself, built in the second half of the fourteenth century, consists of a gateway flanked by enormous round, battlemented towers and ramparts which were constructed as a defence from attack across the river, and to enclose a Benedictine monastery which is now in ruins.

The town below can be explored in an hour or so, as it is comparatively easy to park in the square in the middle of the town and this is quite close to the main places of interest. The church of Notre Dame, only a few yards away, is rather disappointing although it does contain one or two good paintings. Its real treasure is the polychrome ivory Madonna in the sacristy which was carved in the fourteenth century from a curved tusk. The Virgin and Child have an exaggerated backward swing from the waist, following this line—much more exaggerated than the usual rhythmic sway of fourteenth and fifteenth-century madonnas in Europe which were clearly influenced by the ivory carvings. The Villeneuve Madonna,

though of superb workmanship, seems to me to be rather un-balanced with the Child pushing his Mother over backwards.

The Hospice, a short distance from the church, gives the impression of a very dreary, seldom visited provincial museum, but it contains one of the finest primitives to come out of the School of Avignon, or, for that matter one of the finest French paintings of the fifteenth century.

The Coronation of the Virgin by Enguerrand Quarton occupies one wall of a room given over to dull copies and mediocre pictures, but it is of such interest that it captures the visitor's entire attention. It was commissioned by a priest from the Charterhouse who gave the painter detailed instructions as to what he was to include in the picture and, although Quarton conscientiously carried out his wishes, the composition shows his own delightful imagination. It has been criticised as being top-heavy in design, but if it is accepted as being in two parts—an upper and a lower—this effect disappears. It was quite usual in the fifteenth century to paint a main theme on a large panel and then to include background incidents in the predella, a narrow strip let into the frame. It is in these pre-dellas that the painter so often gave free rein to his imagination.

Unfortunately the whole picture has suffered considerable re-painting and restoration, but even so, its impact is over-whelming. The Holy Trinity take the form of two identical figures in crimson robes trimmed with gold, and a white dove places the crown on the Virgin's head. She kneels between the figures clothed in a golden brocade robe with her blue mantle carpeting the ground beneath their feet, whilst behind the group are hosts of angels in vermilion against a golden sky; at either corner St Michael and the angel Gabriel spread deep blue wings echoing the virgin's cloak. This bold conception of colour contrasts with subtle harmonies in the figures on either side, watching the coronation.

Below are scenes from the life of Christ and the old testa-ment set in a fascinating landscape above dramatic renderings

of the fate of the blessed and the damned, and in the middle, Christ on the cross is raised up into the indigo sky.

At one time the superb Pietà which was also painted for the Charterhouse hung here, but it is now in the Louvre and has been replaced by a very dull copy.

The Charterhouse of the Val de Bénédiction is entered from the main street and is of course a whole collection of buildings with dwellings, courts and cloisters. It is a little gloomy and grey but I must admit I have never been fortunate enough to see it on a sunny day. Even so, in the chapel of Innocent VI you will find some rare and lovely frescoes by Sienese painters like those in the chapel of St Martial in the Palace of the Popes. The figures are monumental and he shows great insight into portraiture both with profile and full face. In the *Circumcision of St John the Baptist* his heads, skilfully grouped together to show them to advantage, are all most sensitively and sympathetically painted.

III

VAN GOGH COUNTRY

St Rémy – Glanum – St-Paul-de-Mausole – Vincent Van
Gogh – The Alpilles – Eygalières – Eyguières – Les
Baux – Tarascon – Beaucaire – Fontvieille –
Montmajour – Arles

SINCE distances between the points of outstanding interest
in Provence are so small, any number of places can serve
as a centre. Of these, I myself find that St Rémy is not
only the most practical but the most attractive. To begin with,
if you have plunged right into the heart of the Provence by
arriving by car ferry at Avignon, you can spend a long day
sightseeing in that city and still reach St Rémy before dusk, or
better still, take advantage of the lovely early morning light
and explore the countryside in depth on the way.

Apart from the ring road round the town which becomes
rather busy in the early morning and evening, there is no
traffic to speak of, and the streets and squares which are
shaded with trees and decorated with fountains have serenity
and calm. It is a restful town but certainly not a dull one.
There is an active artists' colony but it does not, as far as I
can tell, include any outstanding painters at the moment, but
they do maintain an atmosphere of interest in the Arts.

The central square is a little mournful with the rather twisted enormous plane trees immortalised by Van Gogh and the streets wind up and down to reveal unexpected courtyards and charming façades. There are any number of hotels and inns at very reasonable prices and one or two restaurants which also let rooms. The Hôtel des Antiques is delightfully situated in a park only a few yards from the centre and is quiet, but it is certainly not in the lowest price range. The Hôtel des Arts on the other hand, is extremely reasonable and gives *en pension* terms but, more important still, the terrace on the street is the meeting place of painters and writers of all ages and nationalities who are more than friendly. In fact, the atmosphere of this place is so attractive, with its vine covered terrace, its long low provençal roof and shuttered windows, that it very much enhances the pleasure of sitting at the café opposite and enjoying its attractive appearance, its colour and its movement.

The restaurants in the town serve regional food and there is an especially good one with a garden overhung with vines, where the *patronne* cooks huge meals of provençal specialities. The menu is simple but it does change each day and the mussels, the fish soup and the *daubes provençales* are particularly good. More elaborate meals, and naturally more expensive ones, can be had in the enchanting garden restaurant of the Hôtel des Antiques.

The town itself is more attractive than remarkable—an attraction which I always find in a small place which has no oustanding monuments within its confines. Even the church is unremarkable but there are some delightful old mansions and two museums, one installed in a sixteenth-century house which once belonged to the Mistrals de Montdragon, specialises in objects of regional interest and is being rearranged. The other and more interesting one is the archaeological collections housed in the Hôtel de Sade, a mansion built from the fifteenth to the sixteenth century which displays the Gallo-Greek and

Gallo-Roman finds from the excavations at Glanum just outside the town, which is the main point of archaeological interest in the area. Some of the Roman remains are much more than fragmentary and the two great monuments, les Antiques, so often reproduced in photographs, are not only in a splendid state of preservation, but they make a focal point of great beauty and interest in their setting of grassland and trees against a background of low hills.

The mausoleum is one of the best of all Roman monuments of this kind and also one which appears to be the best preserved. A square block raised on a plain base is ornamented with bas reliefs and surmounted by a much taller first storey with four arches; the frieze bears the inscription of the rich property-owner and his wife to whom the monument was erected. Above again, a circular collonade surrounds statues of the defunct, but the cone-shaped dome has unfortunately lost its pineapple finial.

Beside the mausoleum stands the municipal arch, one of the many examples of an archway erected to commemorate the founding of a city rather than a triumph in battle. It dates from just before the Christian era and shows marked Greek influence in the quality of the carving and in the handling of the figures, more particularly the chained prisoners on either side of the arch.

The ruins of the city of Glanum on the other side of the road are chiefly of interest to students of archaeology but a sight of these can easily be combined with a visit to the former monastery of St Paul de Mausole, the Maison de Santé where Van Gogh spent some time. It is signposted a short distance outside the town along a turning to the left just before reaching Glanum and is only a few yards off the main road. Even so, the landscape changes dramatically along this narrow, very secondary road. Heathland on either side is undulating and decorated with cypresses; to the right are the intriguing outlines of the Alpilles, the minature silvery mountains rising out

of fields and woods. A wide gravelled terrace runs in front of the long low building and, through an archway to the left, a path leads past flowerbeds directly to the chapel. To the right, stretches the large long garden with the benches under the trees made familiar to us by Van Gogh; to the left, stands a bronze bust of the artist looking very much emaciated and with his ear amputated. The Romanesque church is very simple with a lovely belfry, but the inside is a little plain, having none of the usual embellishments. The Romanesque cloisters are exceptionally lovely for the twin pillars which support the arches are marvellously carved with birds and beasts and foliage, not so richly varied as those at St Trophime, but the general effect is almost as beautiful.

The garden in the centre is a riot of flowers : scarlet salvias, begonias, geraniums and pink roses; the ledges beneath the arch-ways are decorated with plain earthenware flowerpots of geraniums and trailing creepers. The inner walls are covered with climbing roses and jasmine which add their pale colours to the golden-grey of the stone.

It is also possible to visit Van Gogh's bedroom and, considering he was here between the years 1889 and 1890—a period when mental patients were not always treated sympathetically and were seldom given any luxuries—it seems that he was reasonably well-cared for. The room is admittedly simple, but at least during the summer months many a student would be happy to sleep in such a room, looking on to the fields and wooded slopes which surround the monastery. Van Gogh was certainly encouraged to continue his painting even if it were looked on as mere physiotherapy by some of the authorities. The touching letter to the asylum by his brother Théo is hanging on the wall. Written in a beautiful hand, it explains the situation with dignity and frankness, for Théo states that he is seeking entry for his brother with his full consent and that he would hope that the directors of the asylum would give his brother all possible freedom and the maximum

opportunity and encouragement to carry on with his painting. This they most certainly did, and it was here and at Arles that Vincent executed some of his most brilliant canvases.

Vincent Van Gogh was the son of a Pastor of the Dutch Reformed Church who came of a distinguished and prosperous family, but was himself obliged to live in a very modest way. The first house that Vincent knew was of brown brick with shutters and paint work of a depressing dark green, yet it was not unattractive for it stood in a small garden where mignonette and stocks ran riot, quite unlike the average formal Dutch gardens. The surrounding countryside, divided by dykes, was flat and uninteresting and, for a large part of the year, the climate was gloomy and the skies lowering. In the mist and damp of a bad season it must have exuded a deep melancholy. Nevertheless, it had its period of enchantment for a young boy, for the meadows were lush in the spring, when flowers and grasses of all varieties covered the countryside and towards the end of his life when he was painting in the Camargue, he often compared it with his native land.

Although the Van Goghs were not rich, they were certainly not poverty-stricken and the children were brought up with a reasonable degree of comfort. Vincent was devoted to his mother, who was most sympathetic towards him, and his father was kindly and treated him with every consideration, so it is not surprising that the boy had periods of wanting to follow his profession. He also had the affection and sympathy of his younger brother Théo, who was to be such a great support to him throughout his short life.

In 1885, at a time when his son, after a struggle as to whether he should preach or paint, was really at last dedicating his whole energy to painting, Van Gogh's father died. Vincent no longer attempted to reconcile his two careers, though he most certainly did not settle down into a life of calm contentment. His father's death was a great sorrow and made a deep disturbance in his tormented life. But he was now a painter,

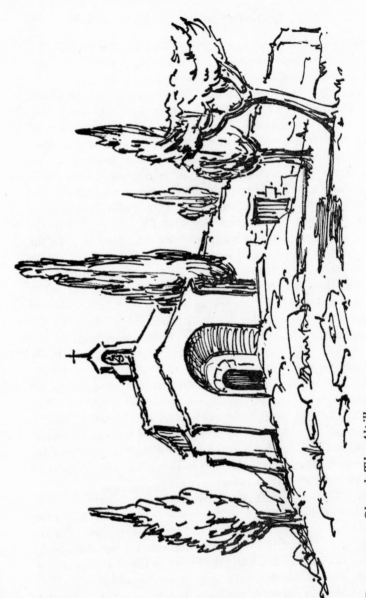

Romanesque Chapel, The Alpilles

working in a frenzy to make up for lost time, and with the vague premonition that he had only a few years in which to create the countless themes he had in mind. He was certain that his whole existence was now to be bound up with painting, and with his father no longer a constant reminder of his abandoned religious calling, he was less assailed by feelings of guilt.

He was now wholeheartedly a painter, working in Holland in the Dutch manner with heavy dark colours, taking such rather sad, sombre subjects as peasants ploddingly engaged in their labours, weavers in gloomy surroundings, landscapes of the dark earth with menacing, though wide, skies.

Towards the end of 1885 he became dissatisfied with what Holland had to offer and was beginning to hanker after more colour, more brilliance and light. He wanted to liberate himself, to get out of Holland and to study the work of Rubens, which doubtless impressed him by its depth of colour. He went to Antwerp and thus began his trek towards the sun, painting his way down to the south and the burning golden countryside of Provence.

It is not surprising that when he began painting seriously in Paris he found the gaiety, the colour and the movement intoxicating and above all, after the grey northern skies, he was overwhelmed with the quality of light and became intensely interested in sunshine and strong colours. Even these luminous skies of Paris did not satisfy his violent craving for brilliant sunlight. Once he decided to take up the career of painting, the history of his life is one of a passionate search for the sun, broken by periods of blank despair. As soon as he forsook his early gloomy manner of painting, everything he created was bathed in the most brilliant golden sunshine, and the most ordinary patch of country, the dullest field or most uninteresting strip of road was turned into a miracle of warmth and colour.

The time soon came when Paris was not enough for him. He

was in a nervous state because of his failure to sell his pictures, dissatisfied with his brother, who he thought could have done more for him, and anxious to find somewhere where the colours were more brilliant. He longed for the clear bright colours of Japanese prints and the sun.

And so he travelled South.

He arrived in Arles in February 1888 when a glory of pink and white blossom and dark tree trunks were decorating the brilliant countryside like a Japanese painting against the clear cut sky line. The glowing earth of Provence and the golden light were a revelation to him—the light which helped to satisfy his obsession for yellow and gave us the Provençal landscapes, both near Arles and St Rémy and the familiar paintings of his own house and the *Café at Arles*. In this last painting the tables on the terrace are enveloped in yellow lamplight, and brilliant stars shine from an indigo sky.

His own house, the Yellow House, used as a centre by his artist friends, was in the Place Lamartine at Arles, but to begin with, it served him only as a studio and he slept at the Café l'Alcazar nearby. It was in this house that he cut off his ear, turning it into a place of horror, for blood had been spattered everywhere and stained towels were thrown on the floor. To add to all this, Van Gogh, as soon as he had staunched the blood sufficiently to go out, wrapped his head in a bandage, pulled an old cap down over his head and took his ear, wrapped in an envelope, to one of the local brothels and left it as a souvenir!

The painter was taken to hospital, where he suffered from hallucinations. He was obviously treated with the utmost sympathy and understanding and was moved into the public ward as soon as he had calmed down. Doctor Rey used to receive him in his office and have long talks with him about matters of mutual interest. Vincent was grateful for all that was done for him here, for he was given every facility to paint. His stay is recorded in his paintings of the hospital, the patients,

the doctor and the courtyard garden surrounded by arcaded terraces and planted with trees.

His friend Roulin, the local postman, a lovable simple looking man with a vast curly beard and kindly eyes—came to see him often. Doctor Rey treated Van Gogh as a brother and gave over his office to him so that he could paint, despite the fact that he did not really understand or admire Vincent's paintings. He went out for walks with him, regardless of the curious stares of the inhabitants of Arles and their amusement at the 'lunatic's' strange clothes and a great red bandage round his head. Van Gogh had a friendship also with the Protestant pastor, Salles, who visited him in hospital and also escorted him back to his home when he was considered fit to return.

But Vincent was not cured. His health worsened and apart from his few friends, the locals looked on him with suspicion and fear. He was mad; what might he not do? They made his life a burden, laughed at him and tried to annoy him.

Finally they petitioned for him to be sent back to hospital, as they said he was a dangerous lunatic. Afraid to venture out, the painter's little house became a prison, and again he came under the care of Doctor Rey.

It was the decision to send him to an asylum at St Rémy that eventually calmed him and gave him the chance to paint some superb pictures of Arles. He felt he would be happy in St Rémy, for he could no longer tolerate the idea of facing life without someone to keep constant watch over him.

Since, to begin with, Van Gogh was not allowed outside the asylum grounds, he found subjects in the garden—a bench under the trees, a fountain, ivy round a tree, pine trees. He painted the interior, too—a chair by the fireplace, a window with bottles, a corridor, and he painted the fields and trees from his window, waiting for the corn to ripen to get maximum brilliance, bringing out the strong lines of the dark green cypresses, twisting them against a cloud-racked sky, underlining the intrinsic drama and rugged simplicity of the scene.

To the south of St Rémy rise the Alpilles, a miniature mountain range of great attraction and to me one of the most exciting and bizarre stretches of countryside in Provence, second perhaps in beauty to the miraculous region to the east of Aix at the foot of Cézanne's St Victoire. It is a curious kind of Patenir moon landscape with marvellously variegated country at the foot of the milky grey-white crags. A stretch of red earth, the precise outlines of cypresses contrast with the sudden slope of a paler red field with silver olives and scrub struggling up the base of the bare stone and petering out at the peak. The cypresses stand out darkly outlined against the soft silver and grey olives, and against the low lines of the vine-yards and the twisted apple trees. Here and there the dark ochre wash of a simple farmhouse glows beneath the almost crimson red of its uneven tiles; then, unexpectedly a smooth green slope gives rise to a miraculously sculptured piece of rock. In contrast, the long horizontal lines of Van Gogh's fields appear green and gold, and even more brilliant gold, against a dense blue sky; then a twisted road and pine trees with their dark foliage bunched against the sky.

There are one or two lovely villages to explore here—villages which keep their original character, but where people with imagination have modified the houses and modernised them so that the villages are cross sections of society with a number of painters, writers and musicians now established there. One such is Eygalières on a height above a secondary road. All the houses are old—cottages and farms and a few sizeable *mas*. The village certainly keeps the ancient customs which are now dying out in France and everywhere else in Europe, for I saw a long sad black cortège of the entire inhabitants of the village winding its way up the hill behind a hearse, to the church of St Sixtus. The café nearest to the church was discreetly occupied in preparing for bumper trade when the service was over and the funeral feast would be celebrated on the terrace by the inhabitants.

Eyguières too, is attractive, but considerably further south-east and on the edge of the Alpilles. It is not as well situated but is in itself charmingly disposed and decorated with a number of fountains.

To the west of St Rémy rise up the ancient fortifications of Les Baux which can be seen outlined against the sky in sinister rugged shapes, the dramatic remains of a once powerful town. Needless to say, it is crowded with sightseers during the season and is a place of pilgrimage for poets and painters because of its romantic setting and ghost-like appearance. During certain hours of the day, sightseers surge through the half-ruined streets and queue up for tables at the hotels and restaurants which have established themselves here to take advantage of the trade. Even so, it is still a place of great interest and beauty and in mid-week out of season there are only a few visitors.

The best time to see Les Baux is by moonlight when the whole countryside is thrown into relief and the towers and battlements of the towns below in the plain shimmer silver in the radiance. At times, when the air is particularly clear, there is a vision of the distant ranges of the Alps covered with snow. Nearer by, the crags form a contrast between the ghostly white on their summit and the deep purple shadows in the ravines.

The Counts of Les Baux claimed to be descended from one of the Magi and so they took as their chief emblem the star of the east which guided the Kings to Bethlehem. At one time they owned no less than 79 towns and villages but when Barral-de-Baux sold the Republic of Arles, of which he was magistrate, to Charles of Anjou, he also put an end to his own power. The present-day Les Baux has only about 250 inhabitants and most of her streets and houses are falling into decay but it must be added also that the more notable and finer buildings have been restored and are now protected by the department of Fine Arts.

The Porte Eyguières or Water Gate was originally the only entrance to Les Baux, but in the nineteenth century a way was

cut through La Maison du Roy—La porte Mage—which is used today. The main street is still lined with the remains of fourteenth-, fifteenth- and seventeenth-century houses, some of them with fine architectural detail.

In the small Place St Vincent, shaded with elms and African Lotus, the Romanesque church of St Vincent and the ruined and restored chapel of the White Penitents, make a most attractive group. On the north wall of the church you will certainly notice a particularly graceful sixteenth-century bell tower with a cupola and gargoyles—the Lantern of the Dead. The portal approached by a flight of steps has been heavily restored, but the interior is remarkable for its three naves and three monolithic chapels hewn out of the rock. Like much of the castle, they date from Carlovingian times and one contains a hewn baptismal trough. Of the three naves, two are Romanesque and the third and smallest is Gothic. Near the altar there is a lovely fifteenth-century carved tombstone. The modern windows, beautifully designed in deep sea blues and greens, give an almost Byzantine glow when the sun shines through the thick uneven glass, diffusing real light, and incredible depth of colour in shade.

The traditional midnight Christmas Mass is still celebrated and takes the form of a medieval mystery play in provençal. Songs, to tambourine and fife, tell of the awakening of the shepherds by the angels and their departure for Bethlehem. A lamb lies on straw in an illuminated cart drawn by a ram and accompanied by shepherds and shepherdesses. At the altar they bow gracefully to the wax figure of the Infant Christ in the manger and curtsey as they pass the lamb.

Just beyond the chapel of St Blaise, the shell of a twelfth-century church and the ruins of the hospital it served, is a terrace with one of the most splendid views of the whole region. The castle on the crag behind this terrace is partially carved from the solid rock and, higher up still, is the Paravelle Tower from which there is an even wider prospect. Indeed

from this point it is possible to see as far as Nîmes and some of the ranges of the Cévennes, and on very clear days the fortified town of Aigues Mortes and the church at Les Saintes Maries-de-la-Mer can be distinguished.

Much further to the west of St Rémy lie the twin cities of Tarascon and Beaucaire superbly situated on either side of the Rhône. These once rather dreamy little towns, forlorn because the tourist traffic did not pass their way, have now lost some of their romantic appeal by the greatly increased traffic on all the main highways and by the fact that several of these merge at Tarascon to pass across the single bridge. Nevertheless nothing can mar the outlines of the towers and fortifications of these cities with the vast expanse of the Rhône swirling between them.

Tarascon derives its name from a fearsome dragon called the Tarasque who roamed the countryside until it was finally subdued by St Martha, the sister of Mary Magdalene. She was able to tame it completely and it followed her about like a pet dog. I know nothing of the further adventures of this devoted couple save that they were looked upon with reverence and respect by the local inhabitants.

The city is surrounded by a shaded boulevard on the site of the former ramparts which were demolished in the nineteenth century. The streets are mainly narrow and one or two of them are arcaded but they are of course crowded with traffic on market days and holidays. At other times Tarascon is a pleasant place with its charming architectural features to discover, since there are a number of old mansions and one or two convents which have remained intact. The Hospital of St Nicolas contains a very good collection of Montpelier faïence, especially apothecaries' jars. The church of St Martha was founded in the tenth century, but it was rebuilt in the twelfth and considerably modified and heavily restored later.

The castle of King René of Provence is splendidly situated on the banks of the river—a simple, superbly proportioned

battlemented building which is one of the most beautiful feudal French castles in existence and in an excellent state of preservation. It was begun in the twelfth century on the remains of a Roman structure and completed in the fifteenth century.

From Tarascon it is a short drive to Arles along the main road but there is also a lovely route from St Rémy along a number of secondary roads. This can be done either via Les Baux or by taking the road past Glanum through the Alpilles and turning right through Fontveille. A turning off here to the left is sign-posted to the much publicised Moulin de Daudet but it is just like any other windmill and its immediate setting is not particularly exciting. Far more exciting is the Abbey of Montmajour nearer Arles which is set in the most fascinating colourful countryside which seems almost to have been created by Van Gogh.

Between Fontvieille and Arles, the Abbey, set in this typical Van Gogh landscape—the golden fields of wheat changed to stretches of silvery brown stubble in autumn—stands slightly desolate at first sight and seems to be part of an ancient farm since the uneven steps and dusty, stony slopes by which it is approached are scattered with scratching chicken, but on the higher level, the flight of steps and the great portal are most impressive. The general forlorn atmosphere is explained by the history of the area which was originally a swamp with the hill of Montmajour rising up in the middle. A Christian burial ground was established and the first Abbey was founded in the tenth century. The only means of access was by flat-bottomed boats since the land between the Alpilles and the Rhône had gradually been inundated. The fifty or so Benedictine monks in residence spent most of their time in draining the marsh for which enterprise 'Pardons' were given to those pilgrims contributing to the fund, and on Fête days in the Middle Ages, there was a great concourse even up to 150,000 souls visiting the Abbey.

In the seventeenth century there were only about 20 monks

and officials left and the religious significance of the processions waned to such an extent that they became almost fashion parades.

In the middle of the seventeenth century, St Maur monks were sent in to restore order and in the eighteenth, the buildings were enlarged and enriched, but by the end of the century the Abbey was suppressed and eventually sold. The new sections were despoiled and the stone used for other projects and all that remains of the original medieval structure was sold to private tenants. Fortunately the nineteenth-century inhabitants of Arles were sufficiently public-spirited to buy the twelfth-century building bit by bit and restore it as it is today, leaving the eighteenth-century additions in ruins.

Beneath the vast and empty Romanesque church there is a crypt which is partly cut into the rock, since the ground is sloping, in the form of a cross with a central and radiating chapels. To me, the most interesting and beautiful part of the church is the cloisters which have much in common with those at St Trophime at Arles, to be described later, and those already seen at St Paul de Mausole. Most of the capitals are Romanesque and depict strange beasts and natural forms; along the inner cloister walls are grotesque heads carved with great imagination. The air of melancholy in the rather forlorn cloister garden is mitigated by the real beauty of the proportions of the twin pillared arcades which surround it and by the vigour of the carving.

The small chapel of St Pierre on the slope of the hill, which cannot be visited at the moment, was partly carved into the rock when the Abbey was founded and it still keeps its interesting tenth-century sculpture in the Carolingian tradition, and the hermits' dwelling in the natural grottoes.

The keeper of the Abbey Church has the key to the beautiful twelfth-century cruciformed chapel of St Croix, a short walk away outside the Abbey. Set among cypress trees on a stony slope, the tiled roof is surmounted by an open campanile.

Hotel des Arts, St. Remy

This was the Cemetery Chapel for Montmajour and you can still see cut in the rock the tombs of the burial ground.

This is a place to linger in and become enveloped in the Provençal countryside in all its colourful variety. The fields have become more golden since Van Gogh painted them; the cypress trees, the orchards more bursting with life; even the grasses, the wild flowers and the weeds are more intensely vivid. Vincent wrote to his brother Théo: 'The town (of Arles) is surrounded by huge meadows abounding in buttercups—a sea of yellow; right in the foreground a ditch filled with violet iris cuts through these meadows', and then again he writes of the view from Montmajour: 'The contrast between the wild and romantic foreground, and the distant perspective wide and still, with horizontal lines shading off into the chain of Alpilles . . . this contrast is very striking.'

I can never make up my mind whether it is better to go to Arles first, with all its associations with Van Gogh and then meander slowly through the countryside and on to the Abbey and the curious landscape of the Alpilles and finally to the monastery of St Paul de Mausole, or to take the whole process in reverse as I have described it here, for it seems to have a rather different significance in each direction.

There is very little to be seen of the places associated with Van Gogh in Arles. The famous Café du Soir no longer exists. The Café de Nuit, in the Place Lamartine, has been turned into a bar-restaurant and everything is changed so that there is practically nothing left to remind us of the Dutchman. The bistro on the other side of the square where he lived, was destroyed in the bombing of 1944.

Arles has grown considerably from the enchanting little town with its pretty women that delighted Van Gogh, but it can still be an agreeable place to stay in and almost as central as St Rémy; more so for anyone anxious to make a detailed study of Roman remains combined with an exploration of the Camargue and bathing on its sandy beaches. For me it lacks

the *intime* atmosphere of St Rémy although it has its own fascination especially in the evening and in the early morning. To anyone with a passion for ruins and antiquities it may well figure as the most interesting town in France and the most picturesque city in Provence, but although I delight in its monuments and more especially in the cathedral of St Trophime, the town has the atmosphere of a museum and I would rather come in for the day, especially as it is not much more than half-an-hour's run from St Rémy.

Arles, as one of the largest and most prosperous cities of Roman Gaul, numbered more than 80,000 inhabitants and the wharves were busy with merchandise brought up the Rhône from all parts of the Empire. The Emperor Constantine lived here for a time and a Greek bishop, St Trophime, brought Christianity to the populace. For a while at the end of the Dark Ages, the City became the capital of an independent kingdom which was divided up in the middle of the twelfth century with Arles as a city republic. It was annexed a hundred years later by the Count of Provence. Much of the Roman and medieval architecture has survived despite dilapidation and despoiling.

The Roman amphitheatre has been very much restored in recent times, for the stone and marble facings were used as building material and then it was transformed into a small town with the Arena walls acting as ramparts. Since it has been cleared away, many spectacles are presented here in summer, including the Provençal type of bullfight on Sundays.

In the fifth century, the same fate was suffered by the Roman theatre when priests made use of the pillars and marble in building their new churches, so that there remain only two linked columns intact and a number of broken pillars and bases.

In the Place du Forum, the façade of a temple built into one of the houses of the square is all that remains of the Roman city centre, and nearby is the shell of the Roman baths, of

little interest to any but the specialists, but the Aliscamps, despite the fact that it is now largely spoilt by the encroachment of the railway, the canal, houses and factories, retains a little of its former melancholy atmosphere. This avenue of tombs, like the Appian Way in Rome, was originally a pagan cemetery, then the 'Champs Elysées' or Elysian Fields were taken over as a burial ground by the Christians in the fourth century. Sarcophagi still line the one remaining 'alley' shaded by poplars, though the best of them have been removed to the museums of Christian and Pagan Art in Arles, which have outstanding collections of sarcophagi, statues and mosaics.

The Museum of Pagan Art, installed in the former church of St Anne is, like the Lapidary museum at Avignon, of much greater interest than appears at first sight, since it has the rather colourless impact of any collection of sculpture and fragments unless it is very skilfully presented against a good background.

Although Roman sculpture is generally considered to be very much inferior to Greek, Greco-Roman sculpture, especially when it is on a small scale, often approaches the excellence of Greek carving and even sometimes seems to humanise it. Some of the heads on display at Arles are particularly beautiful, especially the rather damaged marble head of Bacchus. There is also a lovely torso of Bacchus swathed in a leopard skin and a life-size marble head of an unknown woman, who has a rather wistful look on her very intelligent features. The Roman head executed in the first century B.C. but inspired by a fifth-century Greek head, is rather hard and unsympathetically handled compared with the others. Two heads of Apollo and Bacchus are weathered and battered but very attractive. The statue of the Emperor Augustus comes from the central niche of the ruined theatre, and the original of the famous Venus of Arles is now in the Louvre.

The mosaics from the suburb of Trinquetaille are beautifully executed and fascinating in their subject matter, the animals,

birds and trees being designed with great sensitivity. I particularly liked one from a Gallo-Roman villa of the fourth century where a rather fierce but lovable-looking and clumsy tiger leaps forward after a terrified deer but seems very much frustrated by the decorative tree standing between them.

The Museum of Christian Art in the seventeenth-century Chapel of the Jesuits has a most remarkable collection of Christian sarcophagi depicting a whole series of scenes with a great variety of treatment and subject matter, such as *The Crossing of the Red Sea*, *The Life of Jonah*, *The Miracle of the Loaves and Fishes*, *The Raising of Lazarus*. Some are divided into panels by trees which form, with their branches, arches as a kind of framework to the figures. This is a favourite device and is sometimes made most decorative by the patterning of the leaves and by the addition of birds perched on the branches. Most of the sarcophagi have niches for the figures but those for *Abraham and Daniel* are particularly deeply cut. An enormous subterranean gallery extends beneath the museum and was in fact, the sub-structure of the Roman forum. Although it must be of interest to antiquarians, it is very gloomy, very grey and very depressing, but not really dark because it is lighted by the original air vents. It was for some time used for storing grain, but is now completely empty.

The Réattu Museum is housed in the former Priory of the Knights of St John on the banks of the Rhône. Its collection of eighteenth- and nineteenth-century pictures is only of moderate interest but there are some superb Brussels tapestries and also three by Jean Lurçat, the leader of the modern movement in tapestry in France. On the other hand, the exhibits in the Arlaten Museum housed in the fifteenth-century Hôtel de Castellane-Laval are of outstanding interest and variety for anyone interested in local ethnography. Fréderic Mistral, the poet who devoted himself to the revival of the provençal tongue and the continuance of provençal customs, bought the mansion and made the collection himself with the money he won from

the Nobel Prize; he even wrote many of the labels in his own hand. It is very large, but of more than specialist interest for there are such fascinating things as medicinal herbs and magic balms, weights with decorative reliefs from Les Saintes-Maries-de-la-Mer, Arles and Nîmes, and sections for ex votos, models of boats and even an old 'Tarasque' carried in processions in Tarascon. There are, too, galleries given over to the Camargue, to pottery, to faïence and of course to furniture. The costume collection is outstandingly good, more especially since Arlésian costumes are recognised as being among the most beautiful in Europe.

The Place de la République, in the main square of the town, has an Egyptian obelisk in the centre, the only one of its kind to have been found in France. Like the Venus of Arles, it was dug up from the theatre and may have been brought here by the Emperor Constantine. The Town Hall was built by Mansart in 1673 but the clock tower with the bronze figure of Mars was erected in the sixteenth century. The Royal Palace once stood here and for centuries a lion, the emblem of Arles, was kept in a cage in the courtyard.

The real glory of the square and, perhaps, the most wonderful medieval monument in the whole of Provence, is the cathedral of St Trophime, but at first sight the façade is not impressive because it is difficult to see it to advantage as it is not set back from the road. The stone is blackened and the portal seems squat and heavy until seen from the other side of the square when it loses all its heaviness and the very simple basic proportions become evident, set off against the square tower which rises above it.

The original church dedicated to St Stephen, was erected on Roman foundations and rebuilt several times. Traces of ninth-century work can still be seen in the sacristy and in the transept. In the tenth century the remains of St Trophime were brought here and it became known as St Trophime. The cathedral was almost entirely rebuilt in the twelfth century. The lovely

western portal may have been carefully preserved from an earlier date and skilfully incorporated into the new fabric. The Tympanum of *Christ Enthroned* is much like those at Chartres and at St Gilles in the Camargue. The lintel is decorated with the twelve seated apostles and the frieze to the left and to the right dramatise the hopes of the blessed and the fate of the damned.

Supporting pillars, widely spaced, rest on lions and between them stand carved figures of the saints in which the decorative treatment and the extreme richness of detail show marked Byzantine influence. The architecture of the interior is of different periods, the nave being twelfth century and very simple and austere with narrow, lofty side aisles. The choir and the apse were rebuilt in the fifteenth century.

A number of Early Christian sarcophagi with carved panels are in use in the church. In the nave a fourth-century example is used as a baptismal font and another, depicting *The Crossing of the Red Sea*, serves as an altar in the Chapel of St Geniès. A fifth-century sarcophagus in the Chapel of Les Saintes-Maries-de-la-Mer is surmounted by a sixteenth-century entombment.

The superbly lovely cloister of St Trophime is entered from the street on the right of the cathedral. The northern and eastern sides are early twelfth century and the other two sides are a thirteenth-century restoration. Slender twin piers with carved capitals support rounded arches and the much heavier angle and central columns are formed by figures of saints surrounded by foliage motifs. At the north-west angle stands St Trophime, his right hand raised in blessing, his head sympathetically carved with a gentle, serene expression. The figures all have a simple dignity and the long lines of the drapery give height and grace to the short thick piers. Many of the capitals are carved with scenes from the Bible and are full of life and human detail; especially expressive are those which depict horses, for they seem to have some of the rhythmic movement

of early Chinese carving. An odd note is introduced by a relief of St Martha leading her pet Tarasque.

These cloisters reveal all the astonishing genius of the medieval masons in depicting not only the world of the Bible in terms of the world around them, but a world of fantasy conjured up by their vivid imagination.

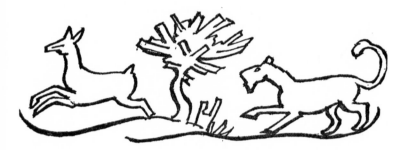

IV

THE EASTERN FRINGES OF PROVENCE

Nîmes – Pont-du-gard – The Duchy of Uzès – The
Camargue – St Gilles – Pont-de-gau – Les Saintes-
Maries-de-la-Mer – Aigues-Mortes

Nîmes is really outside the scope of this book but its
monuments are of such interest that a brief description
of the town may be useful.

Of outstanding interest are the Roman Arena, the Maison
Carrée and the Jardins de la Fontaine, these gardens being
among the most beautiful in France. In the pre-war years, the
Jardins de la Fontaine were quiet. The dust on the roads was
so thick that one could walk almost noiselessly; but a gust of
wind would raise a blinding, choking cloud. Now the silence is
gone, and cars rush by, almost touching the trees or the para-
pets of the bridge. But the stately swans still swim on the clear
water.

The very broad avenue sweeping up to the town centre, with
its three roadways, still has wide spaces with rows of plane trees
overshadowing them. On Sunday afternoons there used to be

crowds of people, old and young, enjoying the shade, and sitting on the cool stone benches. Now every inch of space is used for parking and a walk under the trees is fraught with the peril of being backed into by a car.

The Esplanade at the other end of the avenue, also used to be a favourite place for leisurely walks out of the burning summer sun. Now there are palings all around it, and huge excavators have dug deep so that there will be three levels of garages underground with room for some 3,000 cars. Happily the big trees round the Esplanade have been spared and presumably some kind of garden will be planted over the garages eventually.

Driving in the narrow streets is a work of art, as in many places, for instance in the old Huguenot district there is not room for two cars.

The Arena, or amphitheatre is very much like the one at Arles, but in a far better state of preservation. It was transformed into a fortress in the Middle Ages and later, like the one at Arles, became a village with 2,000 inhabitants. It has been restored to its original aspect and bullfights are held there in the summer.

The Maison Carrée, a Roman Temple almost certainly built by a Greek architect in the first century before Christ, is so beautiful as to belie its extraordinary name. Nothing could be less square in its subtlety of proportion, in the refinement of its columns and in the extreme delicacy with which every part of it is executed. It is the most perfectly preserved temple of this type in existence and this is all the more extraordinary since it has had such an eventful history. At one time it served as a Town Hall, then as a private dwelling, and even as a stable. Colbert suggested to Louis XIV that it should be taken down and rebuilt at Versailles, but instead the King gave it to the Augustinians to serve as a church for their neighbouring monastery. When Napoleon proposed to re-erect it in Paris, the people of the south protested so vehemently that he had to

abandon the idea. Instead he built the church of the Madeleine on the same pattern, but on a much larger scale. It is rather clumsy and has none of the grace of the Maison Carrée which delights the eye with its golden-coloured stone and perfect harmony of form.

The countryside to the north-east of Nîmes, in the triangle formed by Nîmes, Uzès and Beaucaire, is outstandingly lovely and well worth covering in several directions. Directly north lies the chain of the Garrigues, cut across by the deep gorge of the Gardon which winds below the wild rocks. It is even possible in good weather to drive over rather difficult roads and look deep into the gorge, finally reaching a point with a view of the entrance to the Grotte de la Baume on the cliff on the opposite bank.

The main road north-east from Nîmes leads quickly through lovely country to the Pont du Gard, but the very secondary road from Beaucaire is far more beautiful as it follows the course of a tributary of the Rhône for a good deal of the way. The first sight of this Roman aqueduct has almost the overwhelming impact of the Parthenon. Even to those who are not great admirers of Roman architecture and Roman feats of engineering, this magnificent bridge is an absolute revelation. It is as though some giant architect of astonishing imagination had flung masonry across the river to complete the landscape. Here the artist most certainly does improve on nature. Once you have seen the Pont du Gard you cannot possibly imagine that particular piece of countryside or the ravine of the river without it. However much it may be described in technical terms of width of arches and relative height of tiers, the beauty of this marvel of strength and perfection of proportion is impossible to explain.

From the south side of the river, woods slope right down to the water's edge and there is a spectacular view looking up to the span of the aqueduct, but the roadway continues across the first tier to the opposite bank. Here there are no tourist's

boutiques, and out-of-season the large space for parking is practically empty and there is a complete view of not only the splendour of the whole aqueduct but up and down the river. Doubtless, for those who are not given to vertigo, the view from the highest tier of arches is an outstanding one, but then of course, the aqueduct itself no longer takes its place in the landscape.

The Duchy of Uzès which lies to the north-east of the Pont du Gard, is unique in being the only Duchy still existing in France, and it has a very special character. Not only has it some interesting monuments as well as the Ducal Palace, but it is a fascinating place in which to stay for a night or two, especially in spring or autumn, since a broad terrace gives remarkable views of the undulating wooded countryside and the Hostellerie Provençal, though not luxurious, is really Provençal in atmosphere. It is comfortable, friendly and the most attractive restaurant serves excellent regional food and is frequented by people who are interested in the arts and willing to discuss them.

The last time we were there we spent the entire evening over a meal, not because we had so many courses, but because we found the food was certainly worth lingering over, and we became absorbed in conversation with the occupants of three separate tables. A couple from Switzerland were so in love with the Duchy that they were considering building a house nearby, not only because of the countryside but because they found the life and amenities stimulating. There had been an outstanding exhibition during the summer of the works of modern writers, painters, sculptors and architects which had become a kind of social gathering, and from time to time there were original and really good exhibitions, concerts and other events which they enjoyed. Four men at the next table were discussing the merits of modern church architecture and the successful way in which some partly destroyed Romanesque and Gothic buildings had been restored by contemporary

artists and craftsmen, in an entirely live and modern idiom, but marrying perfectly with the existing style. A third group who lived close to Avignon, were describing the qualities of the remarkable modern church at Avignon mentioned in a previous chapter, and indeed we might never have heard of it, had they not pointed it out to us.

There are no luxurious sitting-rooms at the Provençal but the bedrooms are vast, though the stairway to them is very steep. There is no garage, but parking presents no great problem. We noticed other comfortable looking hotels and we sampled several good restaurants, some of them even more reasonable in price, but none had quite the atmosphere of the Provençal.

There is nothing particular to do in Uzès in the evening except to spend a long time talking over a meal or at the terrace of a café. On hot summer nights it is a delight to sit on the broad terrace where the inhabitants come to stroll and chat and get the benefit of the breeze across the valley.

We have strayed rather far from Arles and St Rémy and a little from the main region covered by this book, but these towns are, in fact less than forty miles away by a variety of routes and it is perfectly easy to stay at either and cover it all in a day.

Arles or St Rémy are also good centres for exploring the Camargue, but Arles is the obvious gateway, situated as it is at the apex of the triangular area of partly waterlogged land which reaches to the coast and includes the great salt marshes to the west of Martigues, the fortified city of Aigues-Mortes inland and the sandy fishing villages—now become resorts—of Le Grau du Roi and Les Saintes-Maries-de-la-Mer.

This is a most exciting and often a very colourful region. It is of outstanding interest of course to bird watchers and anyone interested in wild life. Admittedly, special permission has to be obtained to enter the nature reserves but the ordinary visitor, if he is lucky, will see plenty of herds of wild bulls,

plenty of silvery-cream horses and even pale pink flamingoes and snow-white herons.

A word of warning to those who are not familiar with the region. The mosquitoes can be a cause of great discomfort and they are especially active in the autumn, so if you are attractive to these creatures, do not visit it at that time unless very well protected. Secondly, it is no use imagining that you can have an enjoyable walking tour, observing the animals and birds, because it is not safe to go off the roads. Out of season, in compensation, these are practically deserted and even in season if they do not lead more or less directly to the two or three popular beaches.

The marshes and swamps can only safely be covered on horseback, with the help of a *gardien*, the expert horsemen who seem part of their mounts; both they and their horses know every inch of the region and the horses, by instinct, avoid the dangerous shifting bogs.

The best time to explore the Camargue is in the spring when it is almost deserted and not too hot; also then the mosquitoes are less offensive.

For those who do not like flat country, much of the Camargue may seem monotonous, especially the very barren area in the north which has largely been reclaimed for the growing of rice to make up for France's losses from Indo-China. Further south it becomes much more exciting. There are 'ranches' and isolated inns with stabling. Whitewashed walls surround long, low, white buildings where riders can put up for the night or for long stays. Some of these places are far from cheap, quite luxurious in fact, and are filled with people on a riding holiday in the Camargue. Near most of these places the countryside is much more definite, and clumps of trees, big umbrella pines and windbreaks of cypresses break the monotony of the skyline. Tamarisks grow near the swamps and lakes, and all kinds of reeds, grasses and sea flowers flourish in the salt air and the unbroken brilliant sunshine, for there is

practically no shade on the road. In the early morning, in autumn, the dew is so heavy that it outlines the flowers as though with frost, and brings out the distinct character of each type of grass.

Buses do go out from Arles and other towns to the main places of architectural interest and to the sea, but unless you are riding or staying on the coast, a car is almost a necessity.

The road westward from Arles towards St Gilles on the western verge of the Camargue, follows the Petit Rhône and is not of outstanding interest, as it runs through the rather dreary salt marshes. The town itself is dull too, apart from the magnificent façade of the abbey church, but even this appears rather gloomy at the moment as it is very much blackened and not in a particularly attractive setting.

During the course of the twelfth century the west portals of Romanesque churches in Provence became more richly decorated and at the end of the century some buildings, such as the cathedral at Arles and St Gilles, had immense sculptured entrances occupying the whole width of the façade.

The west portal of St Gilles was carried out between 1180 and 1240 by three different groups of masons, all of them taking the theme of the life of Christ. The large central portal is the oldest, by sculptors of the School of Toulouse, but it is not so sensitively carved as those on either side which are the work of artists from the Ile de France, a region which had such a splendid tradition of working in stone. The less successful and sometimes clumsy forms of the apostles in the recesses between the doors were carved by local masons.

As at Arles, the central tympanum represents *Christ in Majesty*, surrounded by symbols of the saints. The left tympanum depicts *The Adoration of the Magi* and the one on the left, *The Crucifixion*, but the most beautiful of all the vivid compositions are those in the frieze under the left tympanum of *Christ's Entry into Jerusalem* and those under the right

tympanum which represent moving scenes of *The Women at the Sepulchre*, of *Mary Magdalene at the Feet of Christ* and the very human incident of the women buying scent. Although this fundamentally magnificent façade is impressive in its richness and variety, the impact is of a very heavy, dark monument until, by examining it in detail, its full splendour becomes apparent.

The interior of the church is without interest, but in the vast twelfth-century crypt you will find the tombs of the Hermit St Gilles, and also a small lapidary museum. To the east of the church are the ruins of the former choir of the church and the Vis de St Gilles, the remarkable spiral staircase in the north tower.

A Romanesque house, traditionally believed to have been the birthplace of Pope Clement IV, has been very heavily restored.

This could be a possible place in which to stay, for those who do not want to spend the night in the Camargue, and I have been often recommended to do this, but I do not like the rather desolate atmosphere of a town like St Gilles whose population has dropped from 30,000 to less than 6,000.

The country from St Gilles to Les Saintes-Maries-de-la-Mer is monotonously flat and empty to begin with, but it gradually gains interest and attraction. There is, however, an air of expectation and the fascination of catching a glimpse of some wild animal or unusual bird, though admittedly these are now inclined to gather well away from the road and are more usually seen in the distance, breaking the flat horizon. At Pont-de-Gau you are certain to see hundreds of the splendid horses gathered together in their pounds on the edges of the ponds, and in the *mas*, the farms where the owners now specialise in breeding horses and the famous black bulls. Here too, you can visit an open air zoo where there are all kinds of rare birds and animals of the district and elegant pink flamingoes standing in a large swamp.

Les Saintes-Maries, just south of the zoo, is of course famous for its great fortified church where the gypsies have their all-night Mass and perform their own strange rites, but it is also well-known for its association with Van Gogh and for the paintings he did of the brilliantly coloured fishing boats drawn up on the almost-white sands. There are still stretches of shore which are deserted, but for the most part, the water front is crowded with bathers although at times it must still look much as it did to the painter in the nineteenth century.

Naturally enough, since this is a popular resort, there are plenty of restaurants specialising in fish dishes and plenty of hotels and places to stay, but all more or less expensive. Even today one can see, in the old village, streets of whitewashed fishermen's cottages with the deep sloping tiled roofs made familiar by Van Gogh's drawings. Along the coast to the west, which is intersected by vast lakes, lies Le Grau-du-Roi and its picturesque canal absolutely crammed with fishing boats of all kinds. On both sides of this main artery, runs a road and a pavement with souvenir shops, restaurants and hotels, several of them with terraces overlooking the canal. It has the rather rakish air of a seaside resort near a large town—in this case Marseilles—but there is added colour in the boats, in the market stalls, in the great heaps of all kinds of rather exotic shells and in the fact that the bathing beach is a certain distance away. This again has superb sands and wonderful bathing.

Any place in this region is saved from being just another holiday resort, as it is coloured by the romantic atmosphere of the Camargue, by the characteristic fishing boats, by the wild life and by the *gardians*, or herdsmen, and their dwellings. They look somewhat like ranch riders with their broad brimmed hats, with their long stirrups and the seats of born horsemen, but their habit of wearing dark or black clothes and of holding the long trident as a standard gives them an aristocratic splendour. These are the men who round up and control

the herds of wild black bulls and sturdy white horses, and they are astonishingly skilful with the use of their tridents, with which they can turn a charging bull. Most of them live a lonely life on the desolate marshes in their *cabanes*, single roomed, thatched and white-washed cottages with a cross at the apex of the roof. They are all windowless on the north side, as a protection against the fury of the mistral.

The only diversions from their life among the animals and the elements are the pilgrimages in the spring and autumn to Les Saintes-Maries and on an occasional feast day in one of the other few towns.

According to legend a boat without sails or oars drifted from Palestine to Les Saintes-Maries. It carried a group of male and female saints including St Mary Jacobé, the sister of the Virgin; St Mary Salomé, the mother of James and John; and Sara, a black servant. All save these three women separated to preach the gospel in Provence, and the tombs of the Holy Marys became an object of pilgrimage. The dusky Sara, despite the fact that she was not a saint, became the patroness of the gypsies. Hence the great concourse, in the spring, of wildly handsome Spanish-looking types in gala gypsy dress which flocks to the crypt of the church where Sara's tomb and statue stand. The church itself is a landmark seen from afar across the flat waste, riding it like a huge battlemented ship, the rounded apse with its upper storey as prow and the tiny slits of windows like portholes. It is not a beautiful building, but its simple, powerful lines make it impressive.

The Romanesque interior of the church is so dark that it is almost impossible to see anything, but in the twelfth-century watch towers over the apse, now a chapel, the bones of the Saintes Maries repose in a reliquary, but those of Sara are two storeys below in the crypt, constructed by King René in the fifteenth century.

On the evening of May 23rd, the gypsies keep an all night watch in the candle-lit crypt as individuals make their petitions

to the overdressed and kiss-worn statue of Sara, and pin photo-
graphs of their friends to her voluminous draperies.

The next afternoon during a special service, the reliquary
of the Saintes is lowered to a position behind the altar so that
the congregation may come forward in the evening to touch it.
The town is crowded with women in the full, flounced skirts
and brilliant shawls associated with the south of Spain; they
are loaded with trinkets and their hair decorated with flowers.
Their menfolk, handsome and gay, stroll the streets, playing
guitars until the streets become a stage for Flamenco dancing.

The third day is the great event of the pilgrimage to the sea
whilst images of the Saintes in a little blue boat, are borne on
the shoulders of gypsies accompanied by the herdsmen on their
white horses, and musicians playing on flutes, and, of course,
a vast crowd of visitors and the local inhabitants rushing to
the sea where the boats are drawn up on the beach. The climax
comes when the *gardians* ride into the surf, the Saintes are
carried down to the waves and the Bishop blesses the sea. The
images of the Saintes are put safely away in their chapel above
the altar and the fourth day is devoted to traditional feasting
and fêting until the gypsies begin to take their leave at dawn.

As one approaches Aigues-Mortes, north westward from Les
Saintes-Maries, the landscape becomes more varied in patches

and the big, cushiony pine trees grow in denser groups around isolated but attractive farmhouses and lend interest to the horizon. Here and there are vineyards, in the autumn, decorated with the bright red and blue shirts of the grape gatherers, whilst there are always several white horses roaming about against the dark trees.

Then desolation sets in again until, like a mirage, the golden ramparts and towers of Aigues-Mortes—the Dead Waters— appear against the brilliant blue of the sky and apparently surrounded by stretches of silver water.

This fairy-tale town used to be so remote and so dilapidated that no one would think of staying there, but it has recently been restored and its stonework has been cleaned. The visual effect of its buildings, especially the wonderful unbroken encircling battlements, the towers and gateways, is sheer enchantment. Inside the ramparts, the town is built like New York, with squares and streets running parallel. There are some houses of great distinction, but for the most part the best views are obtained by standing in the centre of one of the absolutely straight roads which lead from wall to wall and looking out through huge gateways to the Camargue. The main entrance, the Pont de la Gardette, close to the Salt tower, leads into the diminutive high street and past the church to the main square. The church, though not at all well-known, is worth a visit since it is a splendid old Crusader building of great distinction.

St Louis favoured Aigues-Mortes and fortified it to serve as an embarkation point for the Crusaders and as a trading port for the Levant. The Gothic church of Notre-Dame-des-Sablons was begun before the departure of St Louis' first Crusade and was completed at the end of the thirteenth century. The interior is very bare but this is an advantage as it emphasises the beauty of the broad Gothic arches and the quality of the stone.

We were lucky enough to see it with the main gates open for a spectacular wedding. From this perfect setting, the bride

in her long white dress led a procession, with her husband, round the town, cheered on by the inhabitants, though most of them seemed to be her friends and relations. At the same time, the town was crammed to bursting with people coming in by car, by bus or on horseback from the surrounding villages for a regional fête. Outside the ramparts, to the left of the main gates, a fair was in progress and, in the main square within the walls, market stalls were set up, a band was playing and there was a space left for dancing later under the fairy lights and trees. *Gardiens* from the Camargue paraded the town and with them came groups of dancers who stopped every few yards to perform a set piece. It was all very gay; the square was set with tables and chairs provided by the cafés who were doing a fast but simple trade in rather mild drinks and packets of crisps. It was a perfect atmosphere for a popular wedding which was certainly colourful, but a much more interesting wedding in the southern tradition was solemnised near Nîmes and celebrated in the Camargue. On this occasion the families gathered at the very small flat the couple had been lucky enough to rent before they married, and while each in turn got into their best clothes, the others overflowed into the road and decorated the bride's car with tulle and flowers, and tied bows of tulle to the door handles and aerials of the other vehicles. Then once loaded, the caravan of cars drove along main roads to the church, tootling their horns. Policemen smiled instead of whistling and drivers considerately let them pass.

The wedding supper was to take place in the Camargue. The queue of cars wandered along the twisting narrow roads, as the sun set, to a roadside inn where a big hall was decorated with stuffed animals, wild boars and fallow deer, rabbits, game birds, weasels and even the head of a small black bull calf. Amongst other things served were roast boar's leg, and at the end, a tall *pièce montée* and *dragées*.

After the meal, there was dancing to modern music, the tall

sailor husband partnering his bride. Towards the end of the ball, an excited Provençal borrowed a saucepan from the inn-keeper, and started to auction *la jarretière de la mariée*—the object being prettily decorated with tulle. Several of the bride-groom's sailor friends wanted to get it and kept the bidding going merrily, and helped to fill the saucepan. When the bride-groom stopped the auction there were 130 new francs to be handed to him. This was followed by more dancing, and then someone produced a big pair of scissors and cut off bits of the bride's veil to distribute to everyone.

V

THE LUBERON, THE VAUCLUSE AND THE CRAU

The Lubéron – Oppède-le-Vieux – Ansouis – Ménerbes –
Apt – Gordes – Sénanque – Silvacane – Pernes – Le
Thor – Isle-sur-la-Sorgue – La Fontaine-de-Vaucluse –
Cavaillon – Salon – Le Crau

THE broad waters of the Durance separate the Alpilles
from the much larger range of the Lubéron. This rather
mournful region attracts many people because of its
extreme remoteness and its unusual villages, many of which
are romantically ruined and often deserted. Some do retain
remarkable architectural features and undoubtedly the country
to the north—the Plateau de Vaucluse—is of exceptional
grandeur and interest. The Lubéron does not offer much in
the way of amenities, so that apart from those who, in order
to savour its strange atmosphere and acquire a taste for it, are
willing to put up with rather primitive conditions, you would
do well to stay at Apt, Roussillon or the picturesquely situated
Gordes and explore southwards from there.

Some of the villages are very much over-rated even though,

73

like Cadenet in the south with its fourteenth-century church,
they have a monument of interest, but many are superbly sited
on the crest or slope of a hill with narrow streets terracing
gently down. Bonnieux is perhaps the most picturesque of all
with entrancing views over the Vaucluse to Gordes and
Roussillon with the great mass of Mont Ventoux beyond. The
modern church has some sixteenth-century paintings depicting
the life of Christ.

Oppède-le-Vieux, though some of the houses have been re-
stored, is entirely in ruins on the heights and the gutted houses
are overrun with weeds.

Ansouis in the south-east of the Lubéron, is only of interest
for its *château* with high walls protected by cypresses, but
Cucuron, with its rather dilapidated air, retains its ancient
church and gateway, and to the north not far from Buoux, the
beautiful twelfth-century church and campanile have been
taken over as a *Monument Historique* and so rescued from
complete decay.

Ménerbes, between Bonnieux and Oppède on the northern
slope of the Lubéron, was once heavily fortified and a last
stronghold of the Calvinists who withstood siege for fifteen
months. The fourteenth-century church stands just outside
the village and houses primitive paintings of *St Hilaire of
Arles* and *St John the Evangelist*, both from the Abbey of
St Hilaire near the village of Lacoste, now in picturesque
ruins.

Just off the main road to the north, stands Notre-Dame-de-
Lumières, a place of pilgrimage since the fourth century.

The road follows the river Coulon and eastwards stands
the Pont Julien, a beautifully proportioned and unusually
light Roman bridge of only three arches, the piers being
pierced to facilitate the flow of water when the Coulon is in
spate.

For the archaeologist there are endless possibilities of explor-
ation in the Lubéron, and it is a most varied, albeit rather

mournful country for a walking tour, since there is so much of interest confined within a small area and much to be discovered by the individual among the overgrown ruins. All over the region, but more particularly to the north on the Vaucluse Plateau, the strange *bories* are scattered. These primitive huts are either grouped together in a kind of village or completely isolated. Built of the regional stone which needs no cement, they are either square, oblong or round with a vaulted roof of staggered slabs : some are very ancient, but many have been built in recent times on the original pattern. Although most of them are now used as barns or shelters for animals, in the past a great many were in use as dwellings.

The town of Apt is a flourishing market garden centre as well as producing vast quantities of ochre provided by the colourful cliffs of the region which have given Roussillon its name, but it has as well the remarkable twelfth-century church of St Anne which draws a crowd of pilgrims every July who come to visit the relics of the saint, kept in the Chapel Royal. A fourth-century sarcophagus serves as an altar in a chapel which also displays a Byzantine painting of St John the Baptist against a golden background, and in another chapel a beautiful twelfth-century Romanesque High Altar is in the Byzantine tradition. But this is not all : the Treasury has a collection of early manuscripts, twelfth- and thirteenth-century shrines decorated with Limoges enamels, gilded fourteenth-century Florentine coffers and an Arab standard brought back from the First Crusade. The upper Romanesque crypt incorporates Roman capitals and a sarcophagus in the altar, and the lower crypt was constructed considerably earlier.

Gordes presents a wonderful skyline to the west as it clambers up the steep sides of a slope, but it has been a little too much 'taken over' by restorers and interior decorators, with the result that the people of Provence are apt to call it *très snob* and it has lost some of its charm. On the credit side it must be conceded that many delightful houses have been preserved and

the little town has a prosperous air. Its great attraction lies in its proximity to the Abbey of Sénanque.

From any point of view the Abbey of Sénanque is one of the most perfect existing monasteries in the Provençal Romanesque style. It was founded in 1148 and has miraculously been preserved in its entirety, largely due to the fact that it is situated in a remote valley off very secondary routes and was not subject to attack and pillage.

The Valley is indeed secluded today and is approached by a winding road from which there is suddenly a view down to the Abbey cradled on a fertile strip between wooded slopes. Even at first sight it is obviously complete and the modern wing on to the gardens does not detract from its beauty.

The most striking thing about the Abbey is its state of perfect preservation, so perfect that for an instant it seems to have been superbly restored; but nothing restored could have this tremendous impact. On entering the vast dormitory, the perfection of proportion, the sweep of the vault of the roof and the light coming from the round window and the smaller windows along the side is indeed a miracle in all the purity of the Cistercian approach to building. Indeed it might be austere, were it not for subtle and simple decoration to give variety. The corbels supporting the ribs have only a stepped curve, but it is just sufficient for perfection. The central nave of the Abbey church is the most remarkable achievement of perfectly ordered architectural unity, progressing in rhythm to the altar with just the simplest accents, ornamentation which is part of the architecture, not added decoration. The walls sweep up to the cupola and designed brackets stress the thrust and the lift.

The Chapter House is Gothic with palm tree vaulting rising from square capitals, but the scriptorium has the absolute finality of statement of the Romanesque style. One solid rounded pillar on a lightly decorated square base has a capital with leaf motifs supporting rounded arches, but perhaps the

cloisters have even more appeal with their twin pillars sup-
porting rounded arches with just enough carving to add
interest. This is not comparable to the beasts and grotesques
and Bible scenes at St Trophime at Arles, but a quiet confident
statement in the Cistercian tradition which they still affirm
even if they construct a monastery in the twentieth century.
The cloister ceiling has the long lines of barrel vaulting and
the arcades look on to a beautiful little garden of flowers.

A Museum of Romanesque sculpture is being installed in
the Monastery, for its only lack is furnishings of any kind. In
its present state it is so completely bare that it seems almost to
be a perfect example of Romanesque architecture. The five
monks who were living here until March of 1969, left because
it was impossible for so small a number to maintain it, with the
result that its empty rooms have the rather desolate air of
being abandoned.

It is of interest at this point, to consider the smaller mona-
stery of Silvacane, south of the Lubéron on the opposite bank
of the Durance. This is being restored, for it was used as a
farm and has suffered not only damage but dilapidation. It
too has the beautiful calm lines of Cistercian Romanesque, but
the details are blunted and some of the windows filled in with
stone, whilst the cloister pavement is gone and is mud-trodden
by farm workers. The dormitory has been used as a stable, but
restoration is progressing and the general proportions and
superb lines of the Abbey church still give satisfaction as
they have suffered least. The Chapter House is Gothic as
at Sénanque but a little more fanciful with some twisted
pillars.

The setting at Silvacane is very quiet in a rather forlorn
garden away from the road, but it has all the qualities of
silence, austerity and absolute perfection of the Cistercians. In
some ways it is more human than Sénanque, for dilapidated as
it is, it is the dilapidation of constant use or abuse, and the
atmosphere is of beautiful buildings being used for the wrong

Abbey of Senanque

purpose rather than the heart-breaking emptiness of an Abbey abandoned by monks who loved it, because their numbers had drastically decreased. When it is refurnished as a museum, it will, I am sure take on new life.

The valley where Sénanque is so peacefully situated is only one of a dozen small remote valleys in the Vaucluse. The whole countryside varies between quiet secluded fertile regions and dramatic mountain peaks with gorges and rushing rivers. Roads twist and climb through spectacular landscape to points with views into the far distance and to villages and churches remote from the highway.

The small town of Venasque was the seat of the Bishops of Comtat from the sixth to the tenth century, and gave its name to the Venaissin. Built on the foothills of the Plateau de Vaucluse it looks over the plain of Carpentras and is in a delightful setting of orchards on a rock crowned with the towers of an ancient castle.

The late twelfth- or early thirteenth-century church is certainly worth seeing for its Romanesque nave, for its beautiful seventeenth-century bell tower and the late fifteenth-century painting of the School of Avignon depicting the *Crucifixion*, but even more interesting is the Merovingian baptistery, at one time believed to be a Temple to Venus, but now known to have been built in the sixth century and largely rebuilt in the twelfth. A square central hall has a groined vault and semi-circular apses on all four sides, with arcading supported on pink and white marble columns with white marble capitals, some rather roughly carved with Merovingian interlacing. An octagonal baptismal font has been carved out of the stone floor in the centre of the church.

A few miles to the north, the little seventeenth-century chapel of Notre Dame de Vie has a remarkable example of early seventh-century Merovingian sculpture in the form of the Tomb to Bokéthis, the Bishop of Carpentras and Venasque.

If Venasque is well off the highway, the same cannot be claimed for Pernes, Le Thor and l'Isle sur-la-Sorgue, especially this last place since it has the great tourist attraction of the Fontaine de Vaucluse, only a few miles away. Yet all three retain the charm of ancient small towns, almost villages, typical of Comtat. Pernes was, in fact, the capital of the Comtat before it was transferred to Carpentras. The medieval fortifications complete with the flowing waters of the Nesque filling the moats, make a delightful ensemble, and the Ponte de Ville-neuve, with round battlemented towers, was erected in the middle of the sixteenth century and so was the small chapel on the bridge which leads to it; but the Pont Notre Dame is a little earlier in date and has cannon loopholes in its towers. Although these features are most picturesque, of greater interest is the Tour Ferrande, a square twelfth-century tower which has thirteenth-century frescoes on the third storey. Here you will find paintings of Pope Clement IV with Charles of Anjou, the popular subject of St Christopher, the Virgin and Child, and a great variety of battle scenes and tournaments which held such fascination for medieval artists.

Of the old fountains which decorate the town, the seven-teenth-century Fontaine de Cormoran is perhaps the most beautiful.

The twelfth-century Romanesque church was not enclosed by the walls when they were built in the fourteenth century, but the façade was rebuilt.

Le Thor, to the south, also owes much of its charm to flow-ing water; the river Sorgue laps its walls and the avenues are shaded by the great plane trees so typical of Provence. The church which is Romanesque, was rebuilt in the thirteenth century, but its nave is roofed with some of the oldest Gothic vaulting to be seen in Provence. The interior of the church is so dark that it is difficult to make out the details of carving but the decoration of the two portals and of the apse are of outstanding interest. The west portal has an eastern flavour

with its triangular pediment and its slender pillars carved with geometric designs and surmounted by capitals with eagles and plant motifs and the apse is decorated with arcading.

L'Isle-sur-la-Sorgue is one of the most attractive towns in this region, being picturesque, but not irritatingly so, and having entirely unexpected aspects from every angle. Since it is the meeting place of a number of branches of the river Sorgue, waterways—complete with old waterwheels—encircle and transect the town, making it a delight to wander along the quays and turn down the narrow streets and alleyways leading away from them. There are also squares surrounded by plane trees and houses raised on square pillars forming broken arcades. The roof lines are varied, straight or sloping and tiled, made more so by the fact that the houses are of different heights. Among a number of houses of lovely proportions I noticed, particularly down the rue Ledru Rollin, is a house with a carved Renaissance façade.

The Church, which is huge, occupies an enormous space in the Place de la Liberté which also serves as the Place du Marché. The building has little architectural unity nor does it present a very attractive façade, for it was obviously constructed rather halfheartedly during many different periods and in many different styles. One soon discovers that the nave was built towards the end of the thirteenth century and the presbytery at the end of the fifteenth. During the whole of the fifteenth century repairs and enlargements were continually interrupted through lack of money. A desperate attempt to remedy this was made by the imposition of taxes on cloth, on flour and even on bread. Meanwhile the fabric of the church faced ruin and it was decided to rebuild, but even this project did not materialise until 1645 when 'the most illustrious architect of Avignon of the seventeenth century', François de Royers de la Valfenière was commissioned to design it. Much had fallen into ruin and much had to be demolished. The tower which was built as a town belfry in the sixteenth century and

the apse—also of this same period—is surmounted by an open Gothic balustrade.

The interior is considered to be of great interest for its seventeenth-century decorations, which are certainly extremely rich, but seem to me over ornate and rather harsh. The first impression is of deep gloom relieved by gilt for the pillars or ox-blood red simulating marble and the background to the elaborate decorations in the Italian style is deep sky blue. Dark blue serves as a background to hosts of bright gold metal angels which appear to have been glued on; nevertheless this is only the first impression and although this has none of the lightness of Austrian Baroque nor any of the splendour of the Italian, individual statues such as the *Virgin and Child* in the Chapel de Notre Dame du Salat have a serene dignity and the tall figure of *St Peter* is vividly portrayed in rhythmically flowing robes.

Not far from the church, the fascinating Place de la Juiverie is again deliciously irregular and shaded with plane trees; it leads by a short street into the Place des Frères Brun. Here the water flows, protected by a low wall. The wrought iron gateway to the Hôtel Dieu is at once elegant and decorative, its pillars crowned with urns and just sufficiently weathered. A sandy walk leads to the Hospice masked by a group of huge chestnut trees.

The river Sorgue not only enchants the inhabitants of Isle-sur-la-Sorgue but it starts as a fast-flowing stream at La Fontaine de Vaucluse four miles away. The gorge it flows through becomes ever narrower until a steep cliff bars its way and fountains and waterfalls gush out over rocks, ever changing in colour as they gently swirl together over black rocks, form deep blue pools and cross the shallows where flourishing water weeds turn the water to a brilliant, luminous green. In times of flood the river becomes tumultuous and is indeed a wondrous sight. Needless to say, it draws crowds of tourists, yet I have wandered up the few hundred yards from the village on a week-

day in late September and seen only a handful of people, and only one or two of the dozen or so souvenir booths which line the route, were opening up in a rather desultory way. Since so many people come here, it has the advantage of having a number of attractively situated restaurants which serve good food in a range of prices far below that of Paris. Indeed, throughout the whole of Provence, even including the larger towns, charges are much lower than in the north, and of course, than along the popular coastline.

Scenically this torrent is the highlight of the Vaucluse and

it is this marvellous manifestation of nature which most people come to see. In the village below, there is also one of the loveliest churches I have ever seen—lovely, that is, in the utter simplicity of the Romanesque style. The exterior is square and uncompromising in its eleventh-century austerity, but the interior is so superbly proportioned and so perfect in its simplicity, in the soft, pale gold of the stone, in the excellence of its restoration that it is hard to imagine anything more completely satisfying.

Directly south of Isle-sur-la-Sorgue, Cavaillon on the Durance where it begins its flow between the Lubéron and the Alpilles, offers nothing as scenically dramatic as the Vaucluse, but it does offer considerable interest in its Romanesque cathedral and its eighteenth-century synagogue with

Louis XV wood carving, but the archaeological museum is mainly concerned with local prehistoric finds.

The small, delicately decorated Roman 'triumphant' arch in the Place du Clos, is like the one at St Rémy—really a municipal arch. To the left, a pathway leads up to the twelfth-century chapel of St Jacques which was re-styled in the sixteenth and seventeenth centuries.

South again lies Salon to the east of le Crau, the vast stony plain which is gradually being cultivated and industrialised. Its undramatic situation among the olives of the plain does not recommend it to tourists, and some of its monuments are still in the damaged state caused by the violent earthquake of 1909; nevertheless the fortified gateway, the battlemented square tower and the castle built in the twelfth and thirteenth centuries, are very fine and so is the seventeenth-century Town Hall and the thirteenth-century church of St Michael, with its façade of Gothic columns and incorporating Romanesque sculpture in the tympanum.

The fourteenth-century church of St Lawrence, just outside the old town, is one of the finest examples of provençal Gothic architecture, and has a lovely steeple with pinnacles and spire, built over remains of the former Romanesque church. The baptismal fonts appear to be extremely old and may well be Carolingian.

Away to the east, the country becomes more exciting and the heavily restored eleventh-century castle at La Barben is sited on a rock overlooking a dense forest.

Directly to the west of Salon, the plain has been irrigated by waters diverted from the Durance, but westward again it is still a desert of stones.

Legend tells that Hercules, as he was returning to Spain, came face to face with his Ligurian enemies. When he ran short of arrows to use against them, he called upon Jupiter for aid, who caused the heavens to rain down huge pebbles as hail. They have remained there ever since, in some places nearly

fifty feet deep. A turning off the road from Arles to Salon, leads straight through this 'provençal desert', a desolate region admittedly, but with a certain strange attraction as the cultivated area gradually gives way to stones. There are no villages, no hamlets, not even isolated farms but just a few stone huts as shelters for sheep passing from one region to another.

VI

FROM MARTIGUES TO TOULON

MARSEILLES – MARTIGUES – CASTELLAN – AUBAGNE –
GEMENOS – STE BAUME – CALANQUES – CASSIS – BANDOL –
SANARY – TOULON

IT may seem odd to include a huge industrial town like
Marseilles in a book for people who normally seek out
remote regions of character or uncrowded towns which offer
some special cultural attraction. Of course Marseilles is
crowded, and large sections of it are entirely without character
since the reconstruction after the Second World War. Never-
theless it still has much to contribute which is colourful,
interesting and gay; it still has its southern atmosphere and has
preserved some of its monuments. Above all it has its port,
both the old port and the vastly enlarged modern one. With
the Etang de Berre and the country immediately surrounding
it, it does form an area of very definite, albeit rather unusual,
attraction, just as the Crau and the Camargue are fascinating
in their own way. Like the Camargue, Marseilles has two or
three beaches and fishing villages, but it has in addition, an
immediate coastline which is extremely dramatic.

By far the best way to see Marseilles is to stay in one of the smaller old-fashioned hotels on the old port—which, incidentally, can now be by-passed by a tunnel from the motorway, so it no longer gets the full flood of traffic. Here, it is true, there is clamour and crowd but the hotels do have rooms with a view across the port to the church opposite and down to the brilliantly-coloured fishing boats as well as the more commercialised motorboats jostling themselves in the deep blue water. There is always plenty of movement on the water, though this part of the harbour is mainly given up to fishing boats and small craft since the liners now moor in the new docks near L'Estaque. In spite of the reconstruction of the post-war period, the harbour district is still lively and amusing. On the quays there are cafés and restaurants of various categories which specialise in local dishes as well as in the inevitable pizzas and the bouillabaisse. This latter dish is far from cheap—that is, if it is the real thing and not the watery imitation often presented in mediocre restaurants. The real bouillabaisse can never be cheap for most versions of it include fish such as lobster, crab, and even bits of squid, all of which are becoming more and more expensive. Even so, it is still worth the money, especially if accompanied by the regional wine—white Cassis, a vintage developed by an English colonel.

Marseilles is not only the largest and most prosperous sea port on the Mediterranean, it is also the second largest town in France and has about a million inhabitants, made up of a large number of Italians, Spanish, Arabs, Levantines and Negroes as well as members of practically every nationality in the world.

Before the Second World War, areas of Marseilles were really dangerous, more especially the red light district round the port, blown up by the Germans in 1944. It consisted of a maze of narrow, dirty streets where the bars and night clubs and brothels were open twenty-four hours a day to entice the unwary sailors and then relieve them of their possessions. The

drains were stinking, the women looked villainous and it was considered to be dangerous by some to walk around here un-armed. This was, in my experience, grossly exaggerated because it could be perfectly safe for anyone not getting involved with what were obviously doubtful people and places.

The Canebière, the famous principal street of Marseilles, is broad, though quite short, and runs down to the port. It is an important street for it contains most of the main elements of the city—the Stock Exchange, the Chamber of Commerce, the big Banks, the largest shops and the best hotels, cafés and restaurants, though I have found some extremely good restau-rants in the old streets off the port. At all times of the day and night the Canebière is seething with people strolling or rush-ing about, stopping in the middle of the pavement to gesticulate and argue, for the Provençal is unable to talk with-out gesticulating and he seems incapable of gesticulating whilst he is walking. The result is a kind of jerky surge forward.

It was in this street on 9th October 1934 that King Alexander of Yugoslavia was shot by a Croatian terrorist in front of a vast crowd of people.

Marseilles, like Aix, attracts painters and writers who are stimulated by the life and movement and local colour; per-haps indeed more stimulating than the sober, calm, intellectual atmosphere of Aix and its lovely countryside. Most of the Bohemians live somewhere near the Quai de Rive Neuve on the south side of the old port, and, for a time at least, they used to gather in the cafés and taverns of the Rue Sainte, but I have not stayed in Marseilles for any length of time for several years, so they have probably changed their haunts by now, although, since this is virtually all that remains of the old and picturesque part of the town, it is unlikely that they have deserted it altogether.

The atmosphere of the bars and cafés here is friendly and intimate and it is very pleasant indeed to eat at one of the

restaurants with tables set out on the quayside. There are, of course, magnificent views across the quay from the Corniche promenade which runs along the edge of the cliff in the eastern sector of the town, and also has cafés near the water.

Needless to say, a really wonderful view can be had from the height of the hideous church of Notre Dame de la Garde which gives a wide prospect of the mountains round Marseilles, of the harbour and of the coast to the west. It is also worth while taking the popular trip by boat out to the romantic looking Château d'If, the island fortress where 'The Man in the Iron Mask' was imprisoned. His prison is only of sentimental interest, but the journey across the water provides an opportunity of passing through the harbour and of seeing the landscape from a new and delightful angle.

There are view points all over the town which give dramatic prospects of the varied coastline, but it is always an experience to drive along the Corniche and then turn right towards the edge of the cliffs to Calanques—in part a dreary run with ice cream bars and pull-ups, but do not be put off, for the final reward is one of staggering beauty. Below, the rocks in their countless variations of shape and colour break apart to form creeks and coves; they rise up in islets and groups of rocky formations from a sea which forms pools of colour, now violet, now deep blue, now pale green and even the deep green of a pine forest. In the changing light of evening towards sunset and in the silver moonlight this coastline can take on an unearthly beauty.

The town, like the coastline, is also varied in an entirely different way, for here the old and colourful aspect is offset by some admittedly characterless modern buildings, but also by wide, tree-lined avenues and the broad Corniche road which is too wide to be crowded as yet. Typical of the outlook of the Marseillais who hate anything done to rule, the great wide Avenue du Prado takes a right hand bend at a roundabout for no apparent reason since the straight line continues under

another name. In this rather stately avenue lined with offices, the sidewalks under the trees are fully occupied by a busy market and all its stalls and packings which give it a rather incongrous air until mid-day when it is cleared away.

Some of the more interesting museums are close to the Avenue du Prado; the Musée Lapidaire and the Musée Archéologique are both housed in the Château Borély—a fine eighteenth-century mansion still furnished and decorated in its original style. The Musée Lapidaire, in an annexe, has a good collection of regional exhibits as well as examples of Greek, Roman and Early Christian art and finds excavated from the sea.

The Archaeological Museum is devoted to Mediterranean civilisations and contains excellent examples of ancient art from Egypt and the Orient as well as Greek and Roman ceramics and Etruscan and Roman bronzes.

The Musée du Vieux Marseille and the Musée de la Chambre de Commerce, both of more or less local interest, are situated inland at the angle of the Avenue.

The Musée des Beaux Arts mainly stresses the work of artists who lived in the region, but there is also *The Boar Hunt* by Rubens, *The Family of the Madonna* by Perugino, and a small Tiepolo—*The Woman taken in Adultery*. Daumier, who was born in Marseilles, has a good deal of space devoted to his caricatures of Louis Philippe—very striking and extremely frank charcoal sketches and a number of bronzes—but even more interesting are the rooms devoted to the work of the Provençal sculptor, architect and painter, Pierre Puget. His robust Baroque style was not in line with that of the essentially classical artists of the seventeenth century, so although he did produce one great sculpture for Louis XIV—the Milo of Crotona—other works of his were refused and he did not find favour at court. He worked a good deal in Italy and was a pupil of Pietro da Cortona, the architect responsible for the lovely flowing design and perfect proportions of the church of

Santa Maria della Pace in Rome. It was Puget who was responsible for designing the splendid caryatids on the doorway of the Town Hall of Toulon and he did plan a magnificent square for Marseilles but it was never carried out.

For the most part, the interesting individual buildings have to be sought out on a stroll through the less crowded streets of the city, but two of the churches are of outstanding interest: the Basilica St Victor and the Cathedral of La Major situated on either side of the Old Port. The Basilica and crypts of St Victor are all that remain of the former Abbey founded in the fifth century. It was built in the eleventh century, modified in succeeding centuries and very heavily fortified. The most interesting part is the section of the crypt formed by the original fifth-century church.

The modern Cathedral of La Major was built in the late nineteenth century in a pseudo-Byzantine style, colossal and ornate, but the beautiful old Cathedral still stands. The original building was destroyed by the Saracens in the tenth century, reconstructed in the eleventh century and entirely rebuilt in the twelfth; and various additions were made during the sixteenth and seventeenth centuries. With the erection of the new cathedral, a number of changes were made to the old, mainly reducing it in size. Nevertheless the oldest and most interesting portions can still be seen and the church is in fact being transformed into a museum of Christian art which houses a number of superb works including the Reliquary of St Serenus carved with the seated Virgin and Child, a magnificent sculpture of the twelfth century, and a superb late fifteenth-century altarpiece commissioned by King René in the Italian style, complete with putti.

The Unité d'Habitation designed by le Corbusier, is a great landmark in the history of architecture and town planning, for the architect adopted what was at the time (1947–52) a new attitude to mass building, by devising units which were halfway between flats and houses in a huge multi-storey block

flooded with light and also providing communal amenities in the way of a shopping centre, schools and even a day nursery. It is, to my mind a little stark and the façade is rather monotonous, but not so the extremely inventive 'landscaped' roofline with its gymnasium, children's playground and, best of all a superb view over the countryside towards the mountains.

Westwards from Marseilles almost the whole region as far as the salt lakes to the east of les Saintes-Maries-de-la-Mer is taken up with suburbs, with the Etang de Berre and its oil refineries and docks, the aerodrome and the southern tip of le Crau. This may all seem to present a very dreary prospect, but there are in fact pockets of great interest and even of beauty. Cézanne and some of the Impressionists used to come to L'Estaque to paint the sea and the mountains which divides the Etang de Berre from the Mediterranean.

The once attractive fishing villages along the coast are now being encroached upon by the ever spreading docks and general industrialisation of this area, but the Marseillais still flock to the sandy beaches at week-ends when such places as Carry-le-Rouet, Carro and Estaque itself are very crowded. The hills are almost uninhabited but on the northern side, on the shores of the Etang de Berre, Martigues still retains some of its former charm although it is speedily being swallowed up. Nevertheless the colour and lively interest of a small fishing port does not change and the brilliant boats still sway in the water, in the setting painted by the Impressionists. It is built on three islands formed by intersecting canals, like some of the villages in the Venetian lagoon, but pine woods take the place of sand banks. The central 'island' is by far the most attractive and is known as 'L'Ile'!

Much of the pleasure of being in Martigues is found in strolling about and discovering some building of good proportions, a lovely Baroque church, a house of particularly good colour. There is a museum, but it is mainly of local interest or

for those who wish to make a study of the works of Ziem, or other Provençal painters.

Further west, near the aerodrome at Istres, the ancient town of Castellan, of Graeco-Ligurian origin, has been brought to light, but over this whole western region there still remains an aura of ancient Greece and Rome, partly because of the olive yards, the pine trees and the silver rocks, but also because of the clear light which transfigures everything with a shining silver radiance. Here and there are definite remains and more are being discovered. The imposing Pont Flavian, the Roman bridge over the Touloubre has a simple semicircular arch at either end with fluted Corinthian pilasters surmounted by twin lions, though three of these have been replaced by copies. Not far away you will find the remains of a fourth-century Greek city—St Blaise—as well as an early Christian basilica, but these are of interest mainly to the specialist.

Eastwards from Marseilles the new motor road syphons off the crowds who want to reach Nice in a minimum of time, so although all the coastal resorts are crowded at week-ends and in the summer, the coast road and the routes inland running through the forest are much more pleasant than they used to be.

The easterly suburbs of Marseilles now reach Aubagne and beyond, but the enthusiast for old towns may want to see the remains of the old walls, the steep streets and the fourteenth-century church. To the north lies Gemenos and its vast *Château* and Saint-Pons with its beautiful park and Cistercian abbey founded in the first years of the thirteenth century.

Ste Baume is reached by a twisting road over the heights and the scenery is of great beauty, for here the forest is full of huge oaks, yews and hollies and in the spring the ground is covered with wild flowers—lilies, narcissi and orchids.

Thousands of pilgrims still climb to the cave set high upon the side of a cliff, where St Mary Magdalene is venerated. Higher still is the chapel on the summit of St Pilon, a peak

nearly three thousand, five hundred feet above sea level, from which there is a most wonderful view of both the coast and of the plain of Aix and the mountain of Ste Victoire.

The coast road, to begin with, leads through built-up regions with spectacular views out to sea as it winds along the heights to Cassis. There is no access to the shore after the southern point of the Bay of Marseilles for the next ten miles because the

coast is so rugged and so indented. It is here that one can deviate to the right along the rather bad road which, as I mentioned earlier, leads to the best viewpoint of the peculiar, beautiful feature of the landscape—the *calanques*—the narrow rocky inlets into the cliffs where the water is of a dazzling blue in contrast with the white of the cliffs and the fortifications.

Until comparatively recently, Cassis was a typical small fishing port, since fashionable people went to the better-known resorts and the Marseillais kept to the beaches near the cities. Now, as I mentioned earlier, it tends to be very crowded but even so in the off season it retains much of its old charm. The

white houses are in the curve of the harbour and, in spite of recent industrial developments, fishermen still spread their nets on the quayside and locals still sit at the café tables near the waterfronts. Behind, the hills are set in a kind of amphitheatre which seems to enclose the whole of the town. Away from the port, the narrow streets of old houses converge on a small dusty square surrounded by trees, and a short distance beyond, stretches real country with the vineyards which produce the famous local wine. There are one or two so-called artists' cafés on the quay, but since the painters have found calmer and more unspoilt places they have lost their character. Good bathing is still to be had from the shingly beaches which slope quickly down into clear, deep water. The road runs inland for a while and then reaches the coast again at La Ciotat which is a good deal bigger than Cassis, is beautifully situated on a small bay and has a fine beach of white sand with pine woods nearby.

Apart from the superb bathing, it is rather lacking in character, unlike Bandol along the coast, where the small front is planted with palm trees and, in the early spring the gardens are full of mimosa. An attractive seventeenth-century fort stands on a jutting promontory; fishing boats anchor in the harbour and the nets are spread out on the stone walls.

The resort of Sanary, in the next bay, is a kind of smaller edition of Bandol and was a favourite resort of writers between the two wars.

The road leads on to Toulon which, since it was flattened in the Second Great War, has lost much of its charm, though a few old streets still exist a little way inland and at night the soldiers and sailors saunter about in search of entertainment. There is a sound of music nearly everywhere—concertinas, tinkling guitars and small dance bands make a cheerful noise, sometimes pierced with the weird wailing of Arab songs.

Toulon has one of the finest natural harbours in the Mediterranean, for the huge bay is nearly landlocked and steamers

ply to the suburb of La Seyne and to Tanaris on the far side. Inland, the hills rise up steeply to the heights. In 1942 the harbour was the scene of the dramatic scuttling of the French fleet to prevent it falling into the hands of the Germans as they advanced into the Free Zone of France after the Allied landing in Algiers. The most attractive streets are round the old cathedral, of little interest in itself. The Place Puget, with its dolphin fountain and the flower and fruit market in the Cours Lafayette always offers colour and movement, as does the Quai Stalingrad, the evening promenade in front of the Town Hall adorned with Puget's famous caryatids.

VII

THE CITY OF AIX-EN-PROVENCE

THE COURS MIRABEAU – FOUNTAINS – MANSIONS – CHURCHES
AND MUSEUMS – HÔTEL DE VILLE – ARCHBISHOP'S PALACE –
CATHEDRAL – MODERN AIX

AIX is not only one of the most beautiful cities in Europe,
but it is also the ancient capital of Provence and, with
Toulouse, the principal centre of culture in the south of
France. In a sense Marseilles is also a capital, but it is the
commercial capital of the Midi, the largest port in France and
probably the largest port in the Mediterranean.

One has to remember that Provence was in the past not
only, though very loosely, one of the states of the Holy Roman
Empire, but that it was for a while an independent country
with its own ruler, the last of whom, King René, bequeathed
his kingdom to Louis XI of France who inherited it in 1486.
However Provence retained a great deal of independence,
having its own parliament and its sovereign court of justice
with its own traditional laws. Provence was not completely
assimilated until the centralisation effected during the French
Revolution. In the present day, Aix still has the aura of a

capital city of a small state with its own traditional art, music and architecture.

The Festival of Music in Aix is too well known to need describing here, whilst the ancient university still flourishes today as the University of Aix-en-Provence and Marseilles, for some of the faculties are in Marseilles, but the arts and the Fine Arts are in Aix. The university has conferred on the city an intellectual prestige which has never been relinquished.

Aix is, in a sense, like a smaller Paris, for it divides up into 'quarters'; it has distinctive cafés and restaurants in each and every section, at least in the city originally within the ramparts. Each has its own character and monuments. This town really needs an entire book devoted to its architecture, its museums, its artistic and university life, but I can only hint at its possibilities and describe a few of the monuments. It is obviously a place where one can spend weeks, either in the City itself or in one of the countless villages in the incomparable countryside of the area.

The main artery of Aix, the Cours Mirabeau, is also the most gracious and beautiful part of the city, though modern traffic makes it difficult to see details of some of its best features. The double row of plane trees on either side of the carriageway form an archway of variegated foliage which extends over the wide pavements and makes them a haven of shade even in the hottest weather when there is a perpetual dancing movement of patterned shadow over the café terraces.

The huge and rather graceless Fontaine de la Rotonde rises up in the great circus at the end of this broad thoroughfare. It is thirty-six feet high and sports carved lions, dolphins and genii, whilst three figures symbolic of Justice, Agriculture and the Fine Arts stand high above the jets of water.

Three other fountains splash in the centre of the roadway: the first is the fountain of the Nine Canons, composed of three superimposed basins covered with deep green lichen: the

second is a lumpy object smothered in moss cut down from something less ugly and flowing with water from a hot spring. The third is surmounted by a statue of King René who holds in his hand a bunch of the muscat grapes which he introduced into Provence.

The south side of the Cours Mirabeau is almost entirely taken up with elegant seventeenth- and eighteenth-century houses, whilst the other provides shops, cafés, hotels and restaurants.

The residential side is of course much less crowded and maintains a certain sedateness. The beautifully proportioned mansions have lofty rooms, tall windows and elaborate, yet delicately wrought, ironwork. Some of the doorways are framed by caryatids which support first-floor balconies and the earliest of these are the work of Pierre Puget. The 'commercial' side is crowded all day long and well into the night and it constitutes a parade through which most people have to pass, once or twice a day. In the morning, students can be seen rushing by to lectures whilst others hang around the bookshops, and artists linger over the astonishing choice of materials in the lavishly stocked art shop. Country people hurry along to the market and intellectuals with time on their hands sit at the terraces sipping coffee.

As in all southern towns, by six o'clock it seems that the whole population is strolling up and down under the trees, but here in Aix it is a particularly lively population full of sparkle and wit.

The Café des Deux Garçons has been the hub of the city for many generations, but it is now too expensive for the needy student to patronise it very much, and in common with all cafés famous for their literary and artistic clientèle, it has become a haunt for tourists during the season. Nevertheless, the eighteenth-century decorations subsist, the furnishings are of the simplest and the general effect is one of sober elegance. There is, of course no pop music to interrupt the conversation

and it has something of the atmosphere of the Café des Deux Magots in Paris before it was taken over by tourists.

The Negra Coste also attracts a lively lot of patrons both to its terrace café and restaurant and to its hotel rooms which look down onto the Cours, but students and painters and writers are inclined to find inexpensive rooms and studios in the smaller streets, in the few suburbs or in the nearby country-side.

From the point of view of exploration and sightseeing in the town, the obvious first choice is the Cours Mirabeau and the streets leading off from the residential side. Incidentally on this side, there are some 'old established' discreet shops—very high class *patisseries*—where they sell, in elegant boxes, Calissons d'Aix, made of almonds and sugar by some magical recipe, the ingredients for which in no way convey the subtle taste of this delicious sweetmeat.

It is off this southern sector that you will find the exquisite Fontaine des Quatre Dauphins in a quiet square. Originally this graceful seventeenth-century fountain with its obelisk was to have been surmounted by a bronze statue of St Michael, but a fleur de lis was used instead and then this was replaced by a Maltese Cross in 1830 which in its turn has been replaced by a pineapple. This last modification completes it admirably. There is a Renaissance perfection about this fountain, shaded as it is by a chestnut tree which dapples the grey-white stone of the dolphins as they languidly spout trickles of water into the basin.

It is quite impossible to mention all the mansions worth looking at, but their carved portals and beautiful wrought iron balconies are a constant source of delight when wandering through the streets, Many of them have superb interiors and several are now in use as museums and so are very easily visited.

In this quarter too, stands the Lycée where Paul Cézanne and his friend, Emile Zola went to school, and in the rue du

Quatre Septembre, the most comprehensive collection of faïence from Moustiers, Apt and Marseilles, is housed in the Hôtel Arbaud.

The church of St Jean de Malte is a handsome thirteenth-century building with a graceful fourteenth-century belfry. The interior, despite the seventeenth-century transformation, has kept its unity of design and the columns of the nave seem to sweep up effortlessly and elegantly to the simple, slender lines of the vaulting. The church has no real treasures, though some people may be interested in the painting by Mignard, but this seems hardly worth dallying over when there are so many works of art of the highest rank to be seen elsewhere in Aix.

At the side of the church, the lovely old Priory of the Knights of Malta houses the Musée Granet, called after the Provençal painter, Francis Marius Granet, who gave some 500 paintings to this collection; he was a friend of Ingres who painted his portrait. His fame rests upon these facts rather than upon his intrinsic merit as a painter. Other collections enriched the Museum still further but it is by no means restricted to local painters although its main interest does lie in the French school. There are also a number of excellent Dutch and Italian paintings including some Florentine primitives and Byzantine paintings. The fourteenth-century triptych from the School of Avignon is very imaginative and depicts the Virgin and Child in a cave whilst the shepherds are above with their sheep grazing on luxuriant grass and all set against a golden sky.

The Entremont excavations can only be visited by the specialist, but most of the statuary from this source is on show either here or at Marseilles. The museum has an excellent archaeological section with some fine examples of Greek and Roman sculpture, but the Celto-Ligurian finds from Entremont, which stretches a few miles to the north of the city, carved in local stone, are extremely vigorous in treatment and

unique in that the tradition was not carried on by the conquering Romans who copied Greek sculpture.

The great disappointment of the Musée Granet lies in the lack of any really significant work by Cézanne, whereas it is well stocked with pictures by minor Provençal painters. Certainly now, the price of any of his major works makes them almost unprocurable, but had the Aixois been more appreciative of their most illustrious member before his works became investments, there could have been a really representative collection at a modest cost. Obviously these collectors who generously gave their works, did not recognise his greatness. Even the monument to him by Maillot, commissioned in 1912 for the city, was rejected and now stands in the Tuileries in Paris. Even so, the room devoted to *Cézanne et ses Amis*, though in no way worthy of his greatness, does give a curiously nostalgic and slightly uncanny impression of his struggle for recognition. Here is an opportunity to see a meticulous life drawing, done when he was a student at Aix, a lithograph self-portrait and a delightful little etching, but best of all are the watercolours of the *Montagne Ste Victoire* and the countryside around Aix in which he obtains the most astonishing effect with a few lines and gives radiant colour with magical transparent washes of blue and green.

The large portrait of Cézanne by Herman Paul may convey his physical characteristics, but is not of very much interest as a work of art.

Most of the other museums and churches of importance are in the oldest part of the town to the north of the Cours Mirabeau. Within this area there are streets of medieval houses and mansions of a later date, but at all periods the architects seem to have planned with care to preserve unity and harmony. There are glimpses of cool, shaded courtyards through massive wrought iron gates; there are superbly carved portals, and perhaps an open window will reveal a painted ceiling surrounded by delicate moulding.

I like to wander along the picturesque streets and alleys to the north of the statue of King René and arrive in the Place Verdun with the shock of the huge Palais de Justice, and then the relief of coming into the Place des Prêcheurs with its beautiful mansions, the Hôtel d'Agut and the Maison du Périer, and the graceful obelisk of the eighteenth-century fountain rising above lions and medallions. This was the work of Chastel who managed to combine the inventive power of Bernini with the marked aristocratic restraint required by the people of Aix. The medallions were unfortunately destroyed in 1793, but were restored a few years later.

The church of Ste Marie Madeleine has an ugly, heavy appearance, for its façade was 'attached' in the nineteenth century, but the interior is of great interest, not only for its simple spacious lines but for the treasures it contains, which include an ancient statue said to have been given by Saint Bonaventure in the thirteenth century and a *Virgin* by Chastel. A huge painting of the *Martyrdom of St Paul* has been attributed to Rubens, but the greatest treasure of the church is the Altarpiece of the Annunciation. Only the central panel is here, the wings being in Brussels and Amsterdam and only good copies hanging in the sacristy. This is a really beautiful painting which has been dated as the middle of the fifteenth century but there is a great diversity of opinion as to its authorship. It has been attributed to an Italian, to a Burgundian and to a host of other painters but it is now generally accepted as the work of Jean Chapus of Avignon. It shows definite Burgundian and Flemish influence and it has been established that it was painted for a draper of Aix between 1443 and 1445. The painting is in very good condition and the colours still brilliant. The Virgin kneels in an aisle of a meticulously painted, silvery grey Gothic church. She is clothed in a wonderful golden cloak patterned with medallions of flowers and the angel wears a robe of a strange, soft, deep petunia. The gold and the rose against the silver grey background has an astonishing impact

and although a pillar separates Mary from the angel, the perfect placing of the vase with the lily, links them together.

One of the most delightful squares in Aix is the Place d'Albertas in the rue Espariat which runs almost parallel to the Cours Mirabeau. It is quiet and so unobtrusive that it hardly ranks as a square, with its sober fountain gently trickling, and surrounded by elegant aristocratic houses, one of which—the Hôtel de Boyer d'Eguilles, contains the Natural History Museum. To most people the building itself will be of more interest than the collections, for it is superbly decorated with carved panelling and painted ceilings and doorways of the seventeenth century.

The Place de l'Hôtel de Ville, further north, is full of variety and complete with fountain, like every square in Aix. The Belfry gateway which serves as a landmark to guide one through the maze of adjoining streets is on the site of the entrance gateway used by the founder of Aix, the Roman Consul Sextius Calvinius, in the second century B.C. and it still keeps its white stone foundations though it was remodelled in the early sixteenth century.

The vast Town Hall itself was built in the classical style in the late sixteenth century and is entered by a lovely wrought iron gate of simple design. On the first floor the Bibliothèque Méjanes is a magnificent library given to the town by the Marquis de Méjanes at the end of the eighteenth century. The greatest treasure is the fifteenth-century *Book of Hours* of King René. There are exhibits of absorbing interest on permanent display during the summer months while from time to time a special theme is taken for an exhibition. *Landscape in Book Illustrations from the 15th to 18th Century* was one which particularly interested me. There is a fascinating fifteenth-century edition of *The History of the Noble and Valiant Knight Pierre de Provence*, a story written in the thirteenth century by a Canon and illustrated with delightful woodcuts.

The *Missel de Murri*, produced early in the fifteenth century, is luxuriously illuminated with decorative capitals and encircling beasts and flowers, and the fifteenth-century so-called *Book of Hours of Queen Yolande* has twelve superb miniatures and marginal decorations of animals, flowers and fruit. I particularly liked a book illustrating the 'pilgrimage of the body and soul of William', with its small decorations on vellum and an early seventeenth-century book of travel. There were several beautifully produced books, superbly illustrated with vignettes by Eisen, the popular eighteenth-century engraver and painter.

The Post Office, which was originally the Cornmarket, is elaborately decorated by Chastel with symbolic figures of the River Rhône and of the Goddess Cybele whose foot swings lightly out of the pediment to rest on the entablature.

Adjoining the Place de l'Hôtel de Ville, the market presents a lively scene with its stalls under the plane trees.

In the rue Gaston de Saporta, leading out of the Place de l'Hôtel de Ville, you will find the Musée du Vieil Aix in the Hôtel d'Estienne de Saint-Jean. The rather sober façade was probably the work of Puget, but there is a beautifully carved wooden door, a splendid wrought iron stairway, a bathroom with tiled floor and a delightful little boudoir with a cupola designed by Daret with figures and garlands and a painted centrepiece.

The museum on the ground floor is one of the best of its kind and is remarkable for its collection of model figures which were used in festivals and processions. As well as these, there are small figures for Christmas cribs which could be made to move and represent Nativity scenes.

Still further north, in the Place des Martyrs de la Résistance, is the Cathedral and the former Archbishop's Palace. The inner courtyard of the palace is now the setting for the main events in the Music Festival and the first floor is given over to the famous Museum of Tapestries. The seventeenth-century

building is on a palatial scale and has a particularly beautiful early eighteenth-century portal decorated by Toro, the sculptor from Dijon whose real name was Turreau, and a lovely iron grille and sweeping double staircase with wrought iron balusters.

The great pride of the Tapestry collection is the series of eighteenth-century Beauvais hangings found hidden in the building in the middle of the nineteenth century and now considered to rank with those at Angers and at La Chaise-Dieu as the best in France. For me they bear no comparison with the vigorous, dramatic force of the early tapestries at Angers but some of them do have great charm. They are divided into three groups: Grotesques, the story of Don Quixote and *Les Jeux Russiens*. The Grotesques are designed by Bérain and, compared with the magnificent sweeping design of the Apocalypse at Angers, they are almost trivial, though extremely decorative and attractive, displaying a wealth of imagination. I find that the complicated perspective effects take them rather beyond the realm of tapestry. On a background of a warm, deep yellow an elaborate colonnade and a kind of orangery is the setting for gorgeous birds, animals and architectural motifs of garlands and swags; in the foreground, characters from the Commedia del Arte disport themselves in graceful dances and create an atmosphere of fantasy.

The series of Don Quixote are really pictures in wool and their interest is mainly as illustration, but the '*Jeux Russiens*' —a title which is quite inexplicable—which depicts odd figures eating, drinking and dancing, have all the elegance characteristic of the eighteenth century.

My reactions to the Cathedral are always a mixture of disappointment and delight: disappointment because I can never remember how dark and dreary it is, and delight at the freshness of impact of details which I have so often seen.

The exterior is rather unsatisfactory in appearance, being a

mixture of Romanesque, Gothic and Renaissance styles which do not have any architectural unity. It was built on the site of a Roman temple to Apollo, and traces of this can still be seen as well as considerable portions of the subsequent rebuilding, alterations and additions throughout the centuries. Notice particularly the twelfth-century west doorway, very simple indeed and flanked by tall fluted columns with Corinthian capitals let into the wall. The fifteenth-century Gothic portal, with its pinnacles and niches has lost most of its original statuary except the Virgin on the central pillar. A Renaissance doorway leads into the Romanesque cloisters.

The outstanding feature of the façade is the superb carving of the sixteenth-century doors of nutwood divided into panels with sybils and prophets framed with delicately carved fruit and flowers and small animals. Drapery flows gracefully in simple folds from the youthful bodies of the sybils. The effect of the whole is perhaps a little overpowering in its very deep relief and elaboration, but the individual figures are dignified and impressive and the natural forms are carved with loving care and understanding. The doors are extremely well preserved as they are protected from the elements by shutters which the sacristan will open on request.

The interior of the Cathedral is gloomy and sometimes feels almost abandoned when it is empty, but it is nevertheless of outstanding interest for the treasures it contains. The baptistry is probably fifth century and has a simple perfection though purists might find the sixteenth-century cupola a mistake; it rests on greenish marble pillars which may have formed part of the original temple. To me it is altogether delightful in its Renaissance lightness and grace, with winged heads of angels and garlands of flowers decorating the arches above the Corinthian capitals. Oddly enough, the Romanesque cloister which is very simple with no elaborate carvings has the same kind of Renaissance grace, possibly because of the slender form of its twin pillars, and its architectural unity, though it was

built between the end of the twelfth and the beginning of the thirteenth century.

The choir and the nave are hung with seventeenth-century Flemish tapestries which I must admit I cannot admire, apart from their technical excellence, but the cathedral's most precious possession is the triptych of *The Burning Bush* by Nicolas Froment which also hangs in the nave, locked behind shutters.

King René himself commissioned this picture towards the end of the fifteenth century and he and his second wife are depicted on the wings, kneeling and looking towards the Virgin and Child who are enthroned on the burning bush. Moses watches his sheep grazing in a delightfully detailed landscape as the Archangel Gabriel appears to him, and in the background are the castles of Beaucaire and Tarascon. The brilliant colours are perhaps a little harsh, but the soberly designed wings of the triptych representing the *Annunciation*, are carried out in Grisaille and give a restful contrast; they are, to me, more inspiring than the main picture.

The other primitives of lesser interest, hang nearby : a panel from a fifteenth-century triptych of the *Passion* and another of the *Martyrdom of St Mitre*; the latter may also be by Froment or a member of his school. Very little is known about this painter save that he was active between 1450 and 1490 and was in the service of King René.

West of the Cathedral and just outside the walls, is the seventeenth-century Pavillon de Vendôme in its formal gardens and is a perfect example of the Provençal decorative art of this period. It was built as a country retreat for the Cardinal of Vendôme, a governor of Provence. It is now open to the public as a 'stately home' and contains Provençal furnishings and decorations. For a while this was the dwelling house of Jean Baptiste Van Loo who was born in Aix and was responsible for the decoration of several of the churches and nearby country houses.

In complete contrast to the old town with its numerous patrician mansions, its fountains, its shady *cours* and maze of old streets in the centre, new quarters have sprung up on all sides since the Second World War. Though Aix has preserved its gracious charm and nearly all its monuments of the past, as a university town, it is a city for the young and also because of thousands of young students who come here to study French at all times of the year. Nowhere else in Europe, except perhaps in Padua or in Oxford, do you see so many beautiful young women, beautifully dressed; so many handsome youths impregnated with optimism and gaiety. The new university buildings lie to the south of the old town and in this region too, many striking blocks of flats of original design have been constructed. The old town has a population of 30,000 inhabitants; there are more than 70,000 in the periphery, but they do not spoil the character of the city, in fact they enliven it.

Aix certainly does not rest on its laurels with regard to the arts. It is true that the city has not produced a contemporary painter of the stature of Cézanne, but neither has any other part of France, with the possible exception of Matisse. Nevertheless painters of the first rank come here regularly, attracted by the miraculous light, and local sculptors, weavers, metalworkers and more especially workers in mosaic and faïence can stand comparison with any in Europe.

Exhibitions of contemporary work are frequently held in Aix and in Marseilles, including important one-man shows by, for instance, Van Dongen and by Lurçat.

In 1969 the Musée des Tapisseries, despite its tradition of eighteenth-century Beauvais hangings, held a show of the work of Lurçat who was the leader of the revival of the art of tapestry (in the mid-twentieth century) according to the tenets of the weavers of Angers, but in the contemporary idiom. These had far more impact on me than the eighteenth-century designs, because of their imagination, decorative sense, the intensity of colour and respect for the medium. Above all,

Lurçat produced fantastic colour with an unbelievable economy of means. One entitled *Bleu de Bleu* is self-explanatory and ranges through indigo and black to sky blue and violet, pointed with a touch of red. Another hanging—*Earth, Fire and Water*—is designed in deep deep yellow, brilliant yellow, lime and dark earthy brown with the sun a shocking yellow. Earth colours of the sun and fire, the movement of plants growing upwards from the earth, the flowing rhythm of water, create an astonishing atmosphere.

In *The Tropics*, a burning sun cuts right across the design which is bordered with black; brilliant tropical plants burst into flower and butterflies flutter their exotic wings, recalling the fifteenth-century tapestries woven along the banks of the Loire.

VIII

THE CÉZANNE COUNTRY

'Go to Aix for a day and you will stay there for a month' is a worn-out statement, but nevertheless true. The city itself possesses you but, as soon as you glimpse the countryside, you are drawn to explore and explore, more especially the Montagne Ste Victoire and the Valley of the Arc. This is, of course, Cézanne country, and landscape which has a new significance for everyone since he revealed its very bones and structure and we now see it partly through his eyes. In his day you could walk directly from the old town into the country and although he made his home mainly in the rue Boulegon in Aix, he went constantly into the country to paint. He also worked at his studio, Les Lauves, to the north of the town, an unpretentious Provençal villa with nothing to distinguish it inside or out save for the wonderful views from the huge window.

Paul Cézanne was born in Aix-en-Provence in 1839. His father, a well-to-do business man who had owned a hat factory and then had become a merchant banker, was determined that he should follow him in the business. Paul was brought up with this idea, but he was interested in art even during his school

days and, when he was a student, he was also taking classes at the Art School in Aix. He and Emile Zola were great friends and spent their leisure going on long country walks. Zola used to read his poetry aloud and encouraged Cézanne to write verse, so that Cézanne was as much of a poet as a painter and had not really decided to take up art seriously. Since he was a classical scholar, he was not continually straining to become a painter during his student days for he was very much engrossed in his work and, though interested in art, he was studying law and not aspiring to paint. Gradually his drawings began to mean more and more to him and he felt that art must be his real vocation. Even so, this was still a dream and he did not seriously consider devoting his life to it. To satisfy his family he continued to study law although it was beginning to exasperate him.

In 1859, his father had become sufficiently prosperous to buy a large property, the *Jas de Bouffan* just outside Aix. The house was in a very bad state of repair, but the banker restored it and spent the rest of his life in what the people of Aix considered to be the ostentation of a *nouveau riche*. He had, after all, married one of the work girls in his hat factory, and the fact that his first two children were illegitimate did not recommend him morally. Some people, of course, considered that he was much to be admired for his success. Paul, however, felt awkward and could not bear the aristocratic families considering him their social inferior. The *Jas de Bouffan* obviously pleased him though, at least as a theme for his painting, for it appears again and again in his landscapes.

By this time the idea of becoming a banker was definitely distasteful to Cézanne and he was more and more anxious to take a full-time art course in Paris and he finally persuaded his father to let him go. Once there, he was beset with doubts and returned to Aix, meaning to go back to banking, but instead he concentrated on painting the country round his home.

It is relatively easy to visualise the appearance of Cézanne

for we have a number of self-portraits, many drawings by his friends including a most sensitive pencil sketch by Pissarro, and also photographs. He had a fine strong face, aquiline nose and deep penetrating eyes. Zola describes him at the age of thirty, wearing a battered felt hat and an immense buttoned-up coat, originally brown but faded and spoilt by the rain. He was a little bent, and always restless, his long legs encased in trousers too short for him, his blue socks emerging from enormous laced-up shoes. He was given to furious rages, mostly against himself because he was never able to produce a work to his satisfaction. He would cut up a painting and throw it out of the window without the slightest hesitation. He would storm and rage at a model, perhaps not even a professional one, if she moved a fraction of an inch during long sittings. He was kindly, though, and affectionate and extremely generous to his friends who were often trying to dissuade him from spending all his money on them.

Any studio of Cézanne's was everything that a romantic novel writer could hope for. It was always in disorder and full of the traditional dust and muddle. He could not bear to have it cleaned or even swept because he was terrified that clouds of dust would settle on fresh paint. He threw everything on the floor when he felt like it, and had one enormous table cluttered up with brushes, paints, dirty plates, and anything he needed to help him with his terrible creative struggles. Sketches were pinned all over the walls, canvases were stacked everywhere. He was always re-painting and altering his pictures, or those of them which he did not destroy in a fury. He was not well off, but he did have an assured small allowance and was due to inherit a considerable fortune from his father.

Paul kept changing his mind between working in Paris and Aix, although the countryside round Aix delighted and inspired him. He had periods of utter despair when he was doubtful if he had chosen the right career. Although the more advanced critics were beginning to recognise the Impressionists, scarcely

anyone else was sympathetic towards Cézanne, and the public continued to think him incredibly funny.

It is only natural that this continued failure should have depressed Cézanne who had never been over-confident. He was fortunate, though, in having the friendship of Pissarro, who was always such an encouragement to him.

In 1878, Cézanne was working sometimes in Aix, at others at L'Estaque, and it was at this period that he had so much disagreement with his father, who discovered that he was living with a woman called Hortense and already had a child of six. Cézanne's mother, who had known of this secret liaison, did eventually persuade Cézanne to marry Hortense, and the ceremony took place a few months before the old banker died in 1886. In the meanwhile Cézanne had not lived continuously with Hortense because he had become rather bored with her, although he was devoted to his small son. The mother and child lived mostly in Paris, and the painter always felt himself free to wander about alone. Even after his marriage, although he supported his wife and child, he lived with his 'real' family —his mother and sister Marie. He divided the income his father had left him into three—a third for himself, a third each for the support of his wife and child.

At the beginning of 1882 Cézanne rented a little house at L'Estaque, at the foot of the hill where the rocks and pines that he loved to paint stretched out behind him. From there he wrote delightful letters to his friends, full of sympathy and showing interest in their families, and always observing conventional but charming greetings, especially to their parents, but he reveals very little of his personal life in his writings. Although he had a deep affection for his son and supported his wife in comfort, we know he had a passion for a mysterious woman at Aix and that he asked Zola to help him keep the fact secret by making arrangements about delivery of letters. However, there is not enough known about this even to be exaggerated into a good romantic story.

In a letter to his friend and champion Victor Chocquet he says: 'Finally I can tell you that I am still immersed in painting and that there are wonders to be found in this district which have not yet found anyone to interpret their riches to the full.'

The picturesque little village of Gardanne, south of Aix, was a great favourite of Cézanne's and he painted it again and again. The village itself has the basis of his favourite composition, building up on the triangular principle from a solid base to a hill crowned by a towered church.

Landscape near Gardanne, painted in 1885, shows Cézanne's deep affection for his native countryside and its luminous colour combined with solid form. The subtle grey-blue sky mistily recedes into the distance with a golden luminosity developing behind the mountains of a wonderful violet. The green of the foreground is brilliantly clear and sweeps away from us to meet the superbly built-up harmonies of colour of the nearer slopes. The solidly constructed golden and white cubic houses with their violet windows and warm orange roofs, have their rigid upright lines softened by the rounded foliage of the few trees which, as always with Cézanne, seem actually to be pushing their way up from the ground and to have the texture of wood and foliage, just as the massive range in the background has the texture of rock.

Nothing else gave him quite the same satisfaction as the Provençal landscape. He explains in a letter, written some ten years later, how disappointing he found Talloires on Lake Annecy.

In writing to a painter friend in the summer of 1896, he says: 'When I was at Aix, it seemed to me that I should be better off somewhere else. Now I am here, I long to be back in Aix. My life is becoming terribly dreary and monotonous. . . . To try to overcome my extreme boredom I am doing some painting. It is not much fun, but the lake is very attractive with its surrounding hills and mountains, some of them as

Vauvenargues

much as two thousand metres high, they tell me, but this region does not compare with our part of the country, although it is not too bad. For people born where we were, nowhere else has really any significance.'

Throughout his life, Cézanne had been subject to fits of despair, and as he grew past middle age, he complained perpetually of his failing health. He exaggerated his age, which as he suffered from diabetes, may well have weighed more heavily on him than is normal. In writing to the poet Gasquet, he says:

'Perhaps I was born before my time. I am a painter of your generation rather than of mine. You are young, you have vitality, you can emanate a force and an impulse only possible with those who have real feeling. For myself, I am getting old; I shall not have time to express myself.'

Although Cézanne was depressed about the reception of his work, the select, discerning few were beginning to recognise his genius, and in 1899 Fabbri, an Italian collector who had already acquired an important number of his pictures, wrote to him: 'I am lucky enough to own sixteen of your paintings. I recognise their austere and noble beauty. For me, they represent the finest expression of modern art. Often when I look at them, I wish to tell myself of the emotion I derive from them. Please believe me to be your sincere admirer.'

Towards the close of the century, Cézanne was becoming more and more of a recluse and spending most of his time at Aix painting and looking after his mother, who was old and infirm. He scarcely ever saw his friends and did much of his work from the garden of the family home.

Madame Cézanne died in 1897, and in order to conform to the terms of the inheritance, he was obliged to sell the *Jas de Bouffan*, much to his sorrow, for despite fits of despair, it was here that he had found most happiness and inspiration. With the breaking up of his old home he was increasingly lonely,

for he had cut himself off from his friends and had never had any family life except with his parents.

Until 1902 Cézanne lived in Aix, in an apartment where he had only a small studio. Later, he had a house built for himself on the hill of Lauves overlooking Aix and the Montagne Ste Victoire. Here he lived and worked until his death, and the house still contains his palette and paints and some personal possessions in the studio where he painted his last pictures.

Today it is easy to make a pilgrimage to the places where Cézanne lived and worked and to the countryside which he loved to paint. A suggested route is signposted and I believe that there are coach tours. Even so, the whole countryside reminds me all the time of the painter and it is a delight to come upon one or other of the haunts as it were by accident.

Cézanne was born at number 28 rue de l'Opera, an eastward continuation of the Cours Mirabeau, and had a house at number 23 rue Boulegon, near the Place de l'Hôtel de Ville, where he died in 1906, but he worked at his studio on the road to Lauves from 1902 until his death. The *Jas de Bouffan*, his family home where he decorated some of the rooms, lies outside the town to the west, amidst the tall plane trees which he loved to paint. He painted many views of the park, of the railway cutting and of the Montagne Ste Victoire from this property.

After abandoning his little fisherman's cottage at L'Estaque when it became too industrialised, in 1885, he installed his wife and son to the south of Aix at Gardanne. His search for basic structure and for expressing form with colour, attracted him to paint very definite aspects of the region, so he was happy to rent a little cottage by the quarries of le Petit Roquefavour, with their very marked geometric shapes. He loved, too, to paint along the banks of the little river Arc and, above all, near Ste Victoire. He rented a room at Châteaunoir in a delightful house overhung by a nut tree and this was on the route to le Tholonet, one of the most beautiful stretches of

countryside in the whole of France, with ever-changing views of the Montagne Ste Victoire. This mountain is beautiful beyond all expectation, especially at sunset when the curious chalky rock shines white and rose, the scarred cliffs reveal deep ochre fissures, the pale light stresses the basic shapes which so fascinated Cézanne. The fantastic configuration of the landscape is of deepest dark green vegetation, red earth, strong black tree trunks and white mountain peaks. Here one could linger for hours, or months, or years; it is completely unspoilt, though villas have been built discreetly in the woods. So, too, could one turn southwards to linger along the reaches of the Arc, a rather gentler, but still lovely countryside, or turn up northwards to the Barrage du Bimont and see the peak of Ste Victoire from there, sharply defined above the very green waters and yellow banks. Eastward again, lies Vauvenargues, with still different aspects of it. It is an attractive place, especially the *château* which Picasso bought—rosy ochre against hills and pines with slopes falling away below to a deep valley. There is a little inn here and a good restaurant with a terrace, so in fine weather it would be a lovely place to stay and there are a great variety of walks though they are very much up and down hill.

When the Cézanne country is exhausted, there are plenty of villages and woods to explore within easy reach of Aix. Simply by taking the Route des Alpes one encounters undeveloped country in a few miles. I like to stay at Le Prieuré, an outbuilding of the Pavillon de l'Enfant, with windows overlooking the park. Charges are very reasonable—it is most attractively decorated—and there are facilities for making meals. All the windows on one side look onto a superbly laid-out park, and the Pavillon which is privately owned, is one of the historic buildings of Provence furnished in exquisite taste by the owner who has spared no effort to acquire good furnishings and fittings of the period.

To the east of the Route des Alpes, there is an area of

wooded country along secondary or rather narrow tertiary roads which run beside the small estates of charming properties, all of which are invisible from the main road. Some of these roads are admittedly rather too narrow and twisting and some of them lead to a dead-end before going through woods which are privately owned, but others penetrate through hunting country and occasional small villages and hamlets.

IX

INLAND EAST OF AIX

Barjols – Le Thoronet – Peyrolles – Mirabeau –
Manosque – Gréoux-les-Bains – Riez – Moustiers-Ste-
Marie – Gorges du Verdon – Aups – Draguignan – Arcs

THE region to the east of Aix provides endless opportuni-
ties for driving through lovely scenery and coming upon
remote hamlets and villages, but it is not particularly
varied and does not include many places of outstanding
interest, though Barjols and Lorgues, not far from Draguignan,
and of course, the Abbey of le Thoronet, are well worth seeing.
Barjols is a strange town, very southern, with its waterfalls
and fountains, one in particular, heavily moss-grown like those
at Aix and shaded by an enormous plane tree with a trunk
more than forty feet in circumference. The inhabitants seem
to spend their entire time playing bowls in the long *cours,*
frequently half-occupied with a fair. In January a Mithraic
rite is celebrated in which an ox, with gilded horns and
garlands, is led through the town, blessed outside the fifteenth-
century church, sacrificed, and then roasted by forty cooks, to
the tune of fifes and tambourines, and accompanied by
dancing.

Lorgues, set in delightful undulating country of olives and vines, has a splendid *cours* too, also planted with plane trees. The eighteenth-century church is enormous and has an ornate high altar, believed to be the work of Pierre Puget. The Abbey du Thoronet lies only a few miles to the west, on the other side of the river Argens, but this can be equally well seen by a detour from the main road to the south, which I shall describe later.

Le Thoronet is the third of the three great Cistercian Abbeys of Provence, the other two being Sénanque and Silvacane. All three have a great deal in common : all are set in secluded woods : all are in the austere style of Cistercian Romanesque with majestic proportions and a minimum of decoration. Le Thoronet fell into a state of ruin after being despoiled during the Revolution, but it was successfully restored in the mid-nineteenth century and now reveals the great qualities of Romanesque architecture in its main buildings. The double-arched cloisters are a little squat and heavy in their sturdiness, but the Chapter house is in the Gothic style, with its usual grace.

From Aix it is a very short run up into the hills and to Manosque, one of the most beautiful of the inland towns of Provence. It lies just halfway between Aix and Sisteron, which is on the Route Napoléon. Then, from Manosque there is a secondary road to St Maximin, with its fine church, which passes through rustic scenery and seldom-visited villages.

En route from Aix you will pass through Meyrarques, a few miles out on the edge of the wide valley of the Durance, the torrential river that rushes down through the chasms of the alps, bringing with it the rubble that has created the arid plain of the Crau.

At Peyrolles, a little further on, you will find the interesting Chapel of St Sépulcre, built in the fourteenth century, but in a rather graceless archaic Romanesque style on a trefoil plan and with a belfry.

The bridge near Mirabeau crosses over the rocky bed where the waters are either swirling down in flood or reduced to a trickle over boulders, for the climate here has all the violent reflexes of the south. Inland there can be harsh blizzards, ice and violent manifestations of the mistral. In summer the heat is so intense that sometimes the vegetation grows parched in the early weeks and some of the springs and wells may dry up. The town of Mirabeau consists of little more than a group of grey stone houses round a dusty square with a fountain and some trees where the peasants play bowls. It is quite charming to pass through, but it would hardly be noticed were it not for the name given to it because the land round about belonged to Mirabeau of French Revolution fame.

The road follows the valley of the Durance for some miles and rises slowly as the outline of the little grey town of Manosque on the hilltop is perceived. This town too has added importance from the fact that it became familiar to many people before the Second World War, since it was the setting taken for the film '*La Femme du Boulanger*' which so vividly depicted life in Provence with all its burning passion—passion in spite of the leisurely atmosphere which is only on the surface. There is really very little to see in Manosque itself for its attraction lies in the fact that its walls and houses are part of a splendid landscape.

Approached by a steep hill, the first impression is of the fine old gateway and the little boulevard on the site of the former ramparts. Here and there an odd turret or a portion of the old wall has become part of a house or a terrace and on all sides there are dramatic views either into the depths of the valley of the Durance or northward to the mountains. Even on the most brilliant summer day the stone houses rise so high and the streets are so narrow that one plunges into deep shadows and near darkness under the arcades. The seventeenth-century Town Hall has some interesting medieval relics for Monasque was at one time a republic just like Arles or even Rome.

From Monasque it is very easy to cut eastwards across the Durance and on through Riez to Moustiers-St-Marie and the great Canyon du Verdon or even to work round from here to St Maximin and on through le Tholonet. I, myself, prefer to go to Moustiers on a separate run from Aix, driving through Vauvenargues and then taking the winding road to Jouques and on north again to the Durance but keeping to the east of the main highway and the river.

After crossing a branch of the Durance at Vinon you come to Gréoux-les-Bains which is attractive in a spa sort of way, at least it was when we were there, as it lay very quiet and empty in the sunshine. In fact, compared with some of the fly-ridden places on the other side of the Durance in the Lubéron, we found it rather a rest in its ultra-cleanliness, with its good shops, trim gardens and a public park. The road is lovely enough with the shining river and cliffs and is reasonably varied and colourful, but after Gréoux it becomes excitingly varied, with strips of red earth in the very green valley and fields of delicate lavender shading to silver, dark brownish red vines and black grapes. It then continues through woods and open countryside, with red-roofed, ochre-washed farms superbly sited amid groups of trees, to Riez with its gracious houses, its square and its streets lined with the inevitable plane trees of Provence.

The ancient gateway, the Porte Saint Sols, is attractively situated by a fountain and the town *lavoir* where the women slap away at their laundry against a background of cypresses which surround a hillside cemetery. Through the gateway, a winding street branches off left to the ramparts and, to the right, continues through ancient houses, some with over-hanging upper storeys, old doorways with rounded portals and even remnants of carved stonework and wooden doors with decorative iron hinges and studded with nails. Off this street there is one enchanting tiny square with just room for a small plane tree. This is indeed a place to stay in, for it has a rather

cosy life of its own with cheerful bars and restaurants. There is a great deal of variety in the architecture of the town which still keeps many reminders of its past as an important city, originally a Gaulish centre, then a Roman colony, then a See. Just outside the present town you will see the remains of a temple erected here in the first century A.D. Four tall pillars of grey granite are surmounted by Corinthian capitals of white marble with an architrave. They stress the aura of great antiquity of the region, as they stand a little forlorn in a very green field. Near here stands the Baptistery erected in the sixth or seventh century, one of the few Merovingian structures still extant in France, and now containing a museum of ancient carvings. The Baptistery has four apses and eight antique columns of granite with marble Corinthian capitals surrounding the scant remains of the font; the whole is covered with a cupola.

If Riez is attractively sited and varied, Moustiers-Ste-Marie lies in one of the most dramatic landscapes the south of France has to offer. The setting of this village is wild and rugged, for the arcaded houses are built on the sides of a steeply sloping cliff overhung by massive, rocky crags.

Moustiers-Ste-Marie grew up around a monastery founded in the fourth century; this has now disappeared, but a chapel, founded in the time of Charlemagne and rebuilt in the twelfth century, can still be seen. The church has a Romanesque nave and an unusual Romanesque belfry with rounded arches supported by slim columns such as are often seen in Lombardy. The choir is Gothic.

A half-an-hour's walk away on the heights, the chapel of Notre Dame de Beauvoir is not only interesting in itself but provides a miraculous view over the region. This is also Romanesque with a good porch, small belfry and wooden doors carved in the Renaissance style. In the interior the nave is half Romanesque and half Gothic.

Behind the town, a jagged cleft in the towering crags has an iron chain 240 yards long, slung across it from side to side.

Legend says that a certain Knight, the Chevalier de Blacas, made a vow that he would present the citizens with a golden chain this length were he to return safely from the Crusades. He was unable to afford gold when the time came to fulfil his vow, so instead he produced the present one with its gilded star hanging in the middle.

Obviously Moustiers must have been in close contact with Italy, for in the seventeenth and eighteenth centuries a glazed faïence was manufactured here. The secret of this fine glaze is said to have been brought by a monk from Faenza and it was this, combined with the 'blue of Moustiers' which produced such excellent results. When Louis XIV ordered all gold and silver-ware to be surrendered to the state, there was a great demand for very fine pottery and this Moustiers was able to gratify. There were actually twelve factories supplying this ware which gradually became more highly decorated. Themes of hunting and country pursuits gave way to elaborate mythological scenes with designs supplied by first class artists, and more colours were introduced. These were so popular that trains of mules were employed to carry the ware to the markets, more especially the great fair of Beaucaire. At the end of the eighteenth century, trade began to diminish and by 1873, all the factories had closed down. Marcel Provence, who spent so much time and energy in safeguarding old Provençal customs and crafts, instigated the revival of Moustiers faïence in 1925. As in the eighteenth century, acknowledged artists were called in to design the pottery, using flowers and butterflies of the region as motifs.

Some of the ancient Moustiers ware is very much sought after by collectors and a great deal of modern work and pottery on traditional lines is on sale in the town. The museum exhibits some particularly fine examples from the seventeenth and eighteenth centuries.

There are spectacular drives along the Grand Canyon du Verdon between Moustiers and Castellane and indeed these

can be extended as far as Grasse and the coast, but the most dramatic is on the road running south out of Moustiers which runs north of the Canyon in a very winding but roughly semi-circular course to Castellane. Just south of Moustiers, the more southerly route, the Corniche Sublime, takes the southern side of the canyon, finally turning up northwards at Comps to join the more northerly one. A reasonably good head is needed for this road, as parts of it go along dizzy chasms, but there are splendid, specially sited viewpoints.

For nearly fourteen miles the river flows through a deep Canyon that was only explored for the first time in 1905. Now a road has been constructed along the cliff overhanging the gorge which is over 2,500 feet deep in places. At various points it is possible to look right down into the depths of the valley whose slopes are covered with a dense vegetation mainly of oak and lime. The rocks are a lovely pale violet grey and the patches of grass a brilliant tropical green. It is possible to find a path down into the canyon, but I should not care to try this without a guide. I have also been told that adventurous spirits attempt shooting the rapids in canoes!

There is a rather devious way down south from Moustiers to Aups and a very much more swerving, twisting one from Castellane to Draguignan, but in both cases it is the means of access rather than the place itself which is really worth while. Admittedly Aups has a beautiful wide *cours* with huge plane trees and splashing fountains and is delightfully situated in undulating country planted with vines and olives. Draguignan is much more of a city, but the approach is through a land-scape of brilliant vegetation, fiercely green grass, deep black-berry brown earth, dark blue hills and strips of pale lime green, and the road from Castellane passes the huge *Dolmen de la Fée*, a slab of rock resting on three uprights. The town itself is rather dull, despite its legendary contests with a dragon—hence its name—despite its very splendid *cours* and gardens, and its few old streets. On market days it takes on new life and

E

colour and loses its rather grey appearance. The Museum and library are very fine, but the real treasures, *le Roman de la Rose*, illuminated in the fourteenth century, with a fifteenth-century *Book of Hours* and a fifteenth-century Latin Bible are only visible at certain times.

At Trans, three miles to the south of Draguignan, a path leads to a bridge over the river Nartuby above the Cascades. It is worth while going on south to Arcs, since this is a place of real character with medieval walls and an eighteenth-century castle, and the church contains a rather lovely altar-piece of sixteen panels. From here, turn back to look at the Ste Rosaline, the former Abbey de la Calle-Roubaud. It is now privately owned, but you can visit the twelfth-century cloisters, the chapel and the dining hall with its frescoes. If you are still anxious to see more manifestations of nature, you can trace your way up north again to the Cascade de Pennafort which rushes down between walls of porphyry.

X

THE NEW RIVIERA AND PICASSO

St Maximin – Massif de la Ste Baume – Hyères – St
Tropez – Massif des Maures – Grimaud – Fréjus –
Cannes – Iles de Lérins – Vallauris – Antibes

SINCE I have already described Provence south of Aix, and
followed the coast as far as Toulon, I propose to keep east
to St Maximin before sloping south through Hyères and
along the Côte d'Azur. This also gives the opportunity of taking
the secondary road east through le Tholonet and along the foot
of the Montagne Ste Victoire, a little longer than the main
highway, it is true, but well worth it. The scenery on the main
road is quite pleasant but not dramatic and the first sight of
the great Basilica is disappointing as it looks clumsy from a
distance.

The town of St Maximin is remembered in history because
Lucien Bonaparte, Napoleon's brother, married the innkeeper's
daughter who was beautiful and intelligent. Lucien spent the
early days of the Revolution here and even took an active part
in local politics. When Napoleon became a general, Lucien
was elected Speaker of the National Assembly. There is a
tradition that he helped to save the basilica from destruction

by the terrorists, but this is refuted by local historians who say that it was saved by a local peasant who protested publicly against this vandalism.

The building is generally considered to be one of the finest examples of Gothic architecture in Provence, but allowance must be made for the fact that Gothic architecture is a style which is alien to Mediterranean countries whose medieval buildings were mainly inspired by Italy or Byzantium. The exterior is plain and rather heavy, although there are very fine details such as the simple entrance portals with good doors. The exterior heaviness is due in part to the fact that the basilica is unfinished and there is no belfry.

The interior consists of three immense and lofty aisles which have the grace of long slender lines. The sixteenth-century altarpiece of the *Passion of Christ* is of great interest and consists of 16 panels surrounding a central picture of the *Crucifixion*. All the scenes are set in decorative landscapes and views of the Palace of the Popes at Avignon, of Rome and Northern Italy, and the Piazzetta at Venice can be discerned. The painter was a man called Ronzen from Venice, but he was probably German or Dutch. You will find a most glorious thirteenth-century cope which belonged to Saint Louis de Brignoles who died in 1297. It is embroidered in coloured silk with medallions representing the Life of Christ and of the Virgin.

Above the ninety carved choir stalls there are some bas-reliefs of excellent design, which are, I imagine, of the same date as the high altar of jasper with bronze ornament.

The organ is a particularly beautiful example of eighteenth-century work and it is said that when the church itself was saved from destruction, it was demanded that the pipes should be melted down, but Lucien Bonaparte rehearsed the organist to play the Marseillaise—a strategy which seems to have saved the day.

The ancient crypt, entered from the nave, was part of a

Gallo-Roman church and contains some fifth-century sarcophagi elaborately carved with scenes from the scriptures. They are said to contain the ashes of St Maximin, St Martha, Lazarus and St Mary Magdalene. A reliquary of gilt bronze is an object of pilgrimage since it is reputed to contain the skull of Mary Magdalene who took refuge in the mountains to the south-west at La Sainte Baume, described in an earlier chapter.

From St Maximin, I like to cut down south-east to Hyères. This route passes through Touvres and then branches more directly south towards Toulon. Only a few miles from the coast, at la Farlède, a narrow signposted turning between two houses cuts eastwards to Hyères. The countryside is really lovely and varied all the way and the last time we took this road on a very hot, sunny day at the beginning of October, there was no traffic at all, even though it was a Sunday.

Hyères is most attractive with its old streets and fruit and flower stalls. There is nothing remarkable to see, though the old church, re-designed in the sixteenth century, has vestiges of its twelfth-century origin and some good Renaissance chapels. The old town on the slopes of the hill has the remains of medieval ramparts and a half-ruined castle. The houses in this quarter are Italianate, the streets are narrow and some of them are arcaded. The new town, on the other hand, is chiefly distinguished for a large grove of palm trees which used to be considered very exotic in the nineteenth century. It is here that the southern vegetation really begins and it is interesting to note that it was largely introduced in the nineteenth century. Mimosa was brought from San Domingo in 1835, eucalyptus from Australia in 1866 and palm trees were first planted by English visitors in the mid-nineteenth century. All these 'tropical' trees seem as though they have grown here for centuries and they flourish exceedingly. In the harsh winter of 1947, which attacked even the south of France with deep snow, I saw mimosa forests in full bloom two days after the thaw had set in and the mistral had died down.

Beyond Hyères there is no coast road for fifteen miles because of the vast area of saltings on the shore, so the highway runs inland on the edge of the Massif des Maures and then branches further inland through the forest of cork oaks for which these mountains are celebrated. It is impossible to get any real idea of this wild and rugged region except on foot, for there are large areas only reached by tracks and even today there are only a few villages, and it is often difficult to find an inn where meals are served.

A southern branch runs south-east to the coast and in the spring and the autumn this road which keeps close to the sea through le Lavandou, Cavalière, Rayol and Cavalaire, is full of enchantment, with wonderful views of the coast until it dips inland to cut off the peninsula and then swerves along its northern coast to St Tropez.

Some of these new-popularised resorts can be absolutely delightful on a hot autumn day when the sandy bathing beaches are deserted and the highway is free from traffic.

Bormes-les-Mimosas is situated on the foothills of the Massif des Maures and retains its character as an ancient town of narrow streets, climbing steeply under arches.

Le Lavandou, a little fishing port right on the sea, with a fine sandy beach, is obviously much patronised by tourists.

Resorts succeed each other all along the coast and the road twists in and out of countless inlets and promontories. In February or even earlier, mimosas flower in every garden and, soon after, the roses take their place and often do not wither until December. Cavalière has another smooth sandy beach, half enclosed by Cap Nègre with its wooded creeks. Then the road winds up a long line of hills and you can look down through gardens, vineyards and olive groves tiered in terraces. Below, the waves froth against the rocky shore or the water shines, smooth and mirror-like in tiny inlets shaded by umbrella pines. Finally, at Cavalaire, a road runs down to the water's edge and sand stretches to the peninsula of St Tropez.

Here, on the beach, stands a monument to the Franco-American troops who landed on August 15th, 1944. This operation was carried out with astonishing swiftness and success and the whole coast was cleared of the enemy within a fortnight. The advance was so rapid that relatively little damage was done and now there is nothing to show that this region was so recently the scene of savage warfare.

The broad mountainous peninsula of Pampelonne thrusts out into the sea east of Cavalaire. There are hamlets and farms among the woods of this promontory but, at present, no good roads, so that there are still some fine beaches to be explored on foot.

Of course St Tropez is built up, but I always like to spend a night there whenever I am near the coast. There is something very special about the light, about the fantastic radiance of the houses, mainly rebuilt since the Second World War, not to be seen anywhere else in the Mediterranean, even in Greece. Admittedly the atmosphere in the harbour is too much of excessive luxury, but the Musée de l'Annonciade, installed in the Romanesque chapel of the Annunciation, makes it an essential port of call for anyone interested in twentieth-century art.

St Tropez takes its name from the Roman saint who was beheaded by Nero for being a Christian. His body was put into a boat with a cock and a dog and set adrift and it finally came to rest on the shore where the town now stands. In June, the bust of this patron saint is carried through the town in a procession, known as the *bravades*, in commemoration of the repulse of the Spaniards when they besieged the town in the seventeenth century.

The life of the town centres round the harbour; in the mirror-like surface of the water the pale, colour-washed houses, the fishing smacks and now the luxury yachts are reflected with the utmost clarity through a sheen of mother-of-pearl. Nets, now mainly orange plastic, are still stretched out to dry

on the stone wharves, although arduous repairing is a thing of
the past. It is astonishing how much of the former charm of
this harbour subsists through the massive onslaught of
fabulously wealthy holiday makers who take it over during the
summer. Even so, there are places where it is possible to stay
at a moderate cost and even along the waterfront there are
restaurants which cater for the slender purse.

Three miles away, beyond the expanse of the bay, the white
villas of St Maxime shine out below the dark wooded ridges of
the Massif des Maures and, on very clear days, the snowy peaks
of the Alps can just be discerned in the far distance.

Away from the harbour there remain narrow little streets
of old houses and although many of them have been trans-
formed by wealthy visitors, others are still owned by fishermen.

Even the dusty square, shaded by the spreading foliage of
huge plane trees, is basically the same as before, but the old
women who sit and knit interminably and the men who play
at bowls, are overshadowed by the eccentrically-dressed
visitors who parade the streets.

Close to the quayside, the former Romanesque Chapelle de
l'Annonciade has been transformed into a gallery of twentieth-
century paintings. These paintings are largely of the region of
St Tropez, but some, by Marquet especially, are of Paris. The
beautiful Bonnard nude is here and a large number of
Segonzac's sombre, bronze and purple paintings. Signac's
landscapes seem to me a little dry, a little too mannered and
almost under the control of his Pointillist technique but his
water colours are beautifully transparent. How superbly
Marquet portrays the mirror-like waters floating in a kind of
luminous space. Derain invests his Provençal pines and red
coast with characters of their own. Van Dongen's work
impresses by its forceful outline and pure colour, and Rouault
impregnates everything he depicts with tragedy. The ever
attractive fanciful Dufy is well represented but Utrillo seems
a little dull among these giants, probably because he has

painted a gloomy portrait of buildings with his usual sensing of its interior and has given it his own unmistakable character, with his nervously agitated trees, and it has none of the delight in the local luminous sky and sea. Apart from the paintings, there are some fine bronzes by Maillol.

The view of the harbour from the top storey window is absolutely superb and from this distance no amount of tourist invasion can mar its beauty.

It is obvious, from the magnificent paintings in the Annonciade, that in the past artists of the highest rank have come from all parts of France and indeed from all over the world to work in St Tropez. Even today, though it is generally classified as 'spoilt', they still come, but more particularly in spring and autumn. There is a risk, though, of being caught by the mistral which blows ferociously and turns the sea into a fury of grey, green waves, blows stinging grit into the eyes and almost tearing one's clothes. When this happens, the answer is to go round the bay to St Maxime where even the winter is mild and the climate is a pleasant one.

The obvious way to Fréjus is along the coast, but although this can be dramatic, it is a little repetitive and the rather roundabout inland route does give one a chance to cross the impressive Massif des Maures over a very winding road, it is true, but through forests and magnificent scenery. It also passes through Grimaud which it would be a pity to miss, for it has a street, the rue des Juifs, with Gothic arcades, a lovely eleventh-century Romanesque church in an excellent state of preservation and the ruins of a sixteenth-century fortress.

From Grimaud it is also possible to see a good deal of the Massif des Maures by taking a twisting road westwards through Collobrières to Cuers, but this is hardly the direction for Fréjus, in the heart of the oak and chestnut forest region—a strange, slightly sinister region abounding in stories of the marauding 'Saracens' under which loose title the Provençals refer to the Moors, the Arabs, the Turks and the Barbarians

Côte des Maures

who tormented them from the eighth to the eighteenth centuries. Even so, the 'Saracens' seem to have taught them a few useful tricks such as extracting resin from the pine trees and the use of the tambourine to accompany dancing on feast days.

Here you can either continue through the forest northwards to join the highway at Vidauban which will take you uneventfully eastwards to Fréjus, or attempt the more adventurous road east from La Garde Freinet and run north at the Col de Gratteloup, following the course of the Couloubrier for some distance until you hit the highway at le Muy.

A few miles before reaching Fréjus the motor road runs eastwards to Nice, siphoning off most of the traffic.

Fréjus is particularly attractive on a Sunday morning when the markets are open and there is a mass movement towards the lovely cathedral, but it is far more than an attractive town with a market and easy access to a pleasant beach, for it has a remarkable number of monuments, Roman as well as medieval, as it was an important Roman naval base. The amphitheatre dates from the time of Caesar and is the oldest in France; the Roman theatre is contemporary with it, but has been heavily despoiled for building material. Of the aqueduct, only a few pillars and ruined arches remain to the northeast of the theatre. Down by the port, linked by a canal with the sea, you will find the Ateliers de Foulons de l'Arsenal which was the army laundry. Here the soldiers' garments were put in tanks of water, mixed with a special kind of earth and then trampled on, rather like making wine. They were subsequently passed through sulphur vapours.

For me, the Cathedral and its precincts are far more interesting than the Roman remains for they are still infused with life and the vivid local characters fill the ancient building and add to the colour of the nearby market.

The Cathedral is beautifully compact although it is made up of different architectural styles. A sixteenth-century

flamboyant portal leads between the baptistery and the twelfth-century tower with its sixteenth-century campanile into the Romanesque nave where there are treasures of the seventeenth and eighteenth century. A medieval wall encircles the lower part of the baptistery and links it to the Provost's house.

These are dead facts and give no idea of the impact of the warm golden stone, of the partly octagonal, partly round, red-tiled baptistery or of the beauty of the decorated arch (a copy of the original) and its delicate soaring pinnacles, half framing a mullioned window above.

The lovely carving of winged beasts and plant forms, above the portal arch, can be seen in the museum, but the carving on the lintel is the original.

On the left of the entrance portal, the fifth-century baptistery has alternating rectangular and semi-circular niches with antique Corinthian pillars of black granite supporting the heavy stone-work of the arches. These are decoratively treated with alternating brick and stone, but the pillars are too slender to give architectural unity and make the masonry they support look clumsy. The upper part is composed of an octagonal drum pierced with windows and covered with a cupola which latter was entirely restored in the twentieth century.

The wooden doors to the cathedral were carved in the sixteenth century with scenes from the life of the Virgin, with representations of St Peter and St Paul and some portraits of unknown characters in medallions. All the panels are carried out with Gothic grace combined with the lovely decorative sense of the Italian Renaissance.

The Romanesque nave is double because there were originally two edifices, one dedicated to St Stephen and the other to Our Lady, but the exact date of each is unknown though they were built on the foundations of an even earlier structure at some time between the eleventh and twelfth centuries.

The cloisters to the north of the Cathedral were built between the twelfth and thirteenth centuries and the lower

gallery is designed in an earlier style than the upper gallery of double pillared arcades where the museum of local archaeology is housed. The peaceful garden is planted with oleanders and has an ancient well.

The Cathedral contains a number of treasures including a very lovely eighteenth-century High Altar, simple in its basic lines but sumptuously decorated, and a remarkable seventeenth-century painted wooden Crucifix, sober in its lines compared with the voluptuous eighteenth-century *Virgin and Child*.

In the middle of the fifteenth century, a patron of the cathedral commissioned Jacques Durandi to paint an altarpiece depicting Ste Marguerite with other saints. This painter, with the better-known Bréa family, was one of the chief members of the School of Nice which flourished from the mid-fifteenth to the mid-sixteenth century. This School was very much under Italian influence, but also shows signs of Flemish and Spanish contact. Since the painters worked almost entirely for the Brotherhood of Mercy, their works are distributed all over the area and we first come across them in Fréjus. Unfortunately little is known about Durandi, but this painting in the Cathedral of Nice gives him a high place amongst the regional artists of the time.

This is not only an extremely decorative altarpiece, each panel framed, as it is, in a golden niche or archway, but the individual figures are painted with great sympathy and with a gentle grace. There is an instinctive feeling for a rhythmic pose and the drapery falls in a flowing design. The colours are deep and sombre rather than jewel-like, but there is a Gothic feeling for detail, combined with Renaissance motifs. The small Crucifixion panel above the lovely figure of St Marguerite is conventionally composed, but moving in its simplicity.

Compared with this altarpiece, the sixteenth-century *Holy Family* is rather pompous, and the nineteenth-century *Arrival*

of St Francis and St Paul at Fréjus is perhaps trivial, but it has a naïve attraction as though it were really an *ex voto*.

Although Fréjus may seem to be almost a museum of Roman and Christian art, there are two strange religious monuments nearby : one lies two miles away to the north-east and is a Pagoda erected by the Indo-Chinese during the First World War and, decorated with dragons and fish and a whole menagerie of animals, it stands beside an Annamite cemetery where are the graves of 5,000 Annamite soldiers killed during that war. To the west of this extraordinary edifice, a mosque made of concrete, coloured red, has been designed, in imitation of the Missiri Mosque at Djenné in East Africa, but it is very forlorn and dilapidated and completely uncared for by any local Moslems there may be.

From Fréjus the coast road passes through a succession of resorts, all too well known and too frequented to be of any real interest except for bathers, though this highway is an enchanting one and has exciting views down into the little bays. Inland it is backed by the Massif de L'Esterel. On the other hand, the inland route from Fréjus is absolutely delightful, passing through small villages and a very varied countryside. Since the motor road runs from just north of Fréjus to Cannes and Nice, both these routes are completely deserted outside the holiday season, because week-enders going to the big resorts hurtle straight along the motor road. From the inland route there are romantic glimpses of little hill towns— so many that they cannot be described—and then the road runs down towards the Bay of Cannes and all its magnificent yachts lined up in regular rows and swaying gently on the deep blue-green water. A luxury yacht bay this certainly is, but it also has gaiety and atmosphere and keeps something of the brilliance of its earlier attraction as a fashionable watering place. The climate is one of the best on the Riviera and the hinterland is altogether delightful. A ceaseless flow of movement enlivens the streets of luxury shops; the flower market

lends extra colour to the quayside, already decorated by the swaying yachts and, beyond are prospects of the Iles de Lérins, and of the purple ranges of the Esterel to the west. Ste Marguerite, the larger and more wooded of these two islands, was the place chosen by Cardinal Richelieu for a fortress in which to incarcerate many celebrated prisoners, some of whom made dramatic escapes.

St Honorat is also covered by a dense forest of umbrella pines and, though it is smaller, it has a more interesting and more varied history. Greek pirates found that fresh water was plentiful and so established a base here, but this may well have been because they admired the peculiar beauty of the scenery. The Romans took over the island later and then it was raided by Saracens, Genoese, Spaniards and then the Austrians. Even today the ruins of a few small chapels can be seen which were built here by the monks who escaped from the mainland when the Barbarians overwhelmed the Roman Empire. Here St Patrick, the founder of the Church in Ireland, studied for many years when it was the centre of Christian learning from which abbots and prelates were sent off to southern Gaul. The community must have been extremely important for it is said that when Saracen pirates massacred the whole population there were no less than 4,000 monks among the dead.

The castle of Lérins, built in the twelfth century, is a fortified monastery and the outer walls of the towers are built to resist attack, though the inside, with the double-arched cloisters and frescoed walls, has all the tranquillity and cultural quality of a monastery.

North-east from Cannes but still south of the motor road, the little town of Vallauris is famous for its potteries and its association with Picasso. The outskirts of this place are really hideous and it is here that the exciting and superbly-made pottery is to be found in the broad and rather boring streets which lead to the attractive old town. Dozens of shops in Vallauris sell pottery, but it falls into two categories: the

brash, cheap coloured figures and ornate jugs of no value, and the superb ceramics produced by the good factories.

However it is the old town with which we are chiefly concerned. Vallauris, 'the golden valley of Mimosas', goes back at least to the Greeks and Romans and was occupied for 500 years by the Gallo-Romans, but it was later repeatedly sacked by Goths and then by Arabs, when it was incorporated into the bishopric of Antibes. In the eleventh century Bishop Adalbert gave his land to the Monastery of Lérins and Bishop Grimaldi developed it into a town a few years later. Towards the end of the fourteenth century, further invasions reduced the population and a century later a virulent plague practically wiped it out. Then, in the fifteenth century, seventy families from the Italian Riviera were settled here to replace the diminished population and these Italians doubtless brought their special knowledge of ceramics to the potteries.

Certainly the inhabitants of antiquity must have used the vast supply of good clay in the neighbourhood to make domestic utensils, but it was not until the fifteenth century that any kind of trade was established, and this was carried out by the small producer carrying his wares by mule to neighbouring villages and towns. Later, schooners calling in at the port took pots and jars away with them and, when the railway came, goods were exported all over the world with comparative ease. It was at that time, at the end of the nineteenth century, that the industry began to develop from being entirely utilitarian into a pottery producing ornamental ware.

The name of Picasso is inseparable from Vallauris for it was he who realised the potentialities of the potteries. Picasso, on a visit from his home in the Golfe Juan, close to Antibes, noticed that at least one pottery—the Madoura—was producing good contemporary designs and he twisted some clay into shapes which were later fired there. He returned and bought a little villa outside Vallauris and devoted himself to working at the Madoura pottery. With his miraculous inventive powers he

created strange birds and beasts, sometimes merely for orna-
ments, sometimes as pots and jugs. Often he decorated dishes
with forceful designs or simply incised them with the head of a
goat or a bird. These new designs were quickly copied by the
other potters with the result that ceramics turned out indi-
vidually by the pottery are now within the reach of anyone's
purse. The quality of colour and glaze is amazing. One has
only to run a hand over the inviting surface to realise at once
that this is pottery of the highest quality and this is evident
even in a humble heat-resistant casserole or dish.

Picasso soon found himself an old factory as a studio and he
collected around him artists from all over Europe, anxious to
try their hand at ceramics and to benefit from his ideas. Of
course he also attracted a number of amateurs as well as
established potters.

In this great 'studio' he could also conveniently work on his
project of *War and Peace*.

He was to decorate the barrel vaulting of the twelfth-
century chapel built by the monks of Lérins when the Bishop
of Antibes gave them his land. On one side Picasso has painted
a chariot drawn by horses of death who kick out with their
hooves at symbols of civilisation; behind, ghostly shadows
perform a kind of *Danse Macabre*, but to the left a radiant
knight, holding a shield with the dove of peace, holds up the
march of war. On the opposite side, humanity is deliriously
celebrating peace and a winged Pegasus draws a plough guided
by a child. The sun shines with a benign eye and figures feast
and dance and play the flute. In the apse, and linking these
two great murals, four figures—black, white, red and yellow—
signifying the different races, are united with their left hands
clasped and their right hands holding the Dove, the symbol of
Peace. It is a staggering achievement, but for me the *Horrors
of War* is a far more impressive painting than the *Joys of
Peace*. Picasso seems to feel this far more intensely and the
deep earth and fire colours, sombre though they be, are far

more satisfying than the primary colours of Peace and the 'United Nations'.

Not only Picasso's ceramics and an important mural are to be seen in Vallauris, but also his bronze of the *Man with a Sheep*. This he carried out rapidly in clay during the course of a day, having first conceived it in countless drawings. When it was cast in bronze, after the war, he offered it first to the Museum of Antibes, but it was not installed there, so he finally gave it to the town of Vallauris and it was housed in the chapel he later decorated. Now it is set up in the cathedral square, an astonishingly powerful statue of a naked shepherd clasping a sheep, the sheep which he was always using in various analytical drawings. It stands among the plane trees, surrounded by market stalls with the lovely eighteenth-century façade of the church to one side and café terraces behind. This is the real centre of the old town and a most lovely one in contrast to the twin square across the road, with its huge, ugly war memorial and the Town Hall.

It was from Antibes that Picasso came to Vallauris and there, in the castle, the Grimaldi Museum is largely given over to his works. They are beautifully presented against the thick whitewashed walls which make a particularly good background for a great variety of his lovely drawings in line, chalk and wash.

Antibes is a dramatic place, especially whenever rough white frothy waves dash against the ramparts and a fresh breeze is blowing.

It is a city of great antiquity for it was, at one time, a Greek fortress and then a Roman garrison. It is entirely encircled by massive ramparts whilst, on the east side, fishing boats and yachts are moored in waters which are usually smooth and blue. Within the ramparts there is a network of narrow streets where a whole colony of painters have established themselves in remodelled fishermen's cottages. The comparative newcomers do not seem to have created a very Bohemian atmo-

sphere and they are not particularly in evidence at the café terraces.

The Cap d'Antibes, the long, wooded promontory that forms the eastern arm of the bay of Juan is still one of the most fashionable resorts of the Riviera. Villas, with splendid gardens, have been built along the waterfront and right at the tip the celebrated Eden Roc still attracts cosmopolitan society.

Whilst Antibes lies on the northern neck of the promontory, the popular sandy beach of Juan-les-Pins lies in its southern curve.

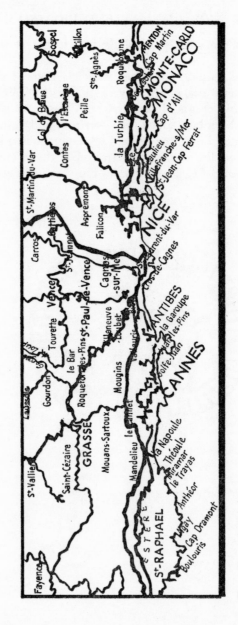

The French Riviera

XI

NICE AND THE PAINTERS' VILLAGES

Nice : Waterfront, Old Town, Market, Place Masséna, Museums – Cimiez and Matisse – Biot and Fernand Léger – Cagnes and Renoir – St-Paul-de-Vence and the Maeght Foundation – Vence and the Matisse Chapel – St Jeannet – St Laurent

THE road east from Antibes is not very attractive or exciting today but until comparatively recently the landscape was dotted with small farms and peasant houses alternating between open country; and there were attractive views of hills and mountains inland. Now, cheap modern villas line the highway and some have been turned into roadhouses with pretentious names and little else to recommend them.

The real appeal of the route lies in the fact that inland the skyline is broken by the exciting silhouette of fortified hill towns, all of which invite exploration. Passing through Cagnes, for instance, along the coast, there is a brief glimpse of the walls and castles of the upper town, a mile or two off the road. On either side of the built-up areas there is also a vista of the wide valley that leads up to St Paul-de-Vence and Vence

perched high on their slopes, covered with cypresses, olive trees and orchards. The Var, a few miles further on, is the boundary line between Provence and what used to be the separate county of Nice, and there is indeed the feeling of passing a frontier on crossing over this river. Now, of course, the original Niçois are submerged by the thousands of French who have settled there. Nevertheless there are still delightful old houses and cottages, Italian in character, and certainly there are inland villages nearby where the local patois predominates and this is a language which is neither Italian nor Provençal but more akin to the dialect of the Ligurians.

Nice is no longer just a resort; it is a huge and growing town, for people from all parts of France come here to retire. Naturally enough the influx has resulted in untidy suburbs springing up along the coast, reaching out towards the Var and obliterating the open countryside which still existed a few years ago.

In spite of all this new development, Nice is beautifully situated in a superb setting of sea and mountains, and it is, even today, a city with an atmosphere of gaiety and liveliness; it is a place where people live and work, as well as play, and yet they succeed in celebrating for a great deal of their time.

Needless to say, along the wide coast roads there is the constant roar of traffic, heavy and light, with the added rasping screech of motor bicycles which seems to go on, without stop, throughout the night. For myself, I am prepared to put up with this noise for the benefit of the miraculous view of the wide sweep of the sea through the shimmering palm trees and of the general colour and movement along the sea front. The Promenade des Anglais is, of course, famous as having been once the fashionable parade of Europe, and it still has its luxury hotels and attracts people from all over the world. Near the port and the old town, it is more picturesque, less crowded and consequently less noisy, with the added attraction of being

close to the fascinating streets of the old town and the huge flower market.

The true Niçois lives, works and plays in the old town and seldom ventures far from it. In this quarter, which is such a contrast to the spaciousness of the Promenade des Anglais, the setting is nineteenth- and even eighteenth-century in character. There are narrow streets, alleyways and flights of steps, thronged all day with lively, chattering people, crowding along the narrow footways and into the shops to buy macaroni, salami, oil, wine and garlic and an immense variety of cheeses. The colourful products overflow onto stalls on the pavements, but unfortunately not nearly to the same extent as they used to. The old town is shrinking visibly every year, for huge supermarkets have stolen much of its trade and many of the younger inhabitants have trickled away to more remunerative work. It is however a delightful and exciting place in which to wander for there remain tall, Italianate churches with belfries like those seen in Lombardy, and even rather down-at-heel palaces which keep their stone coats-of-arms although they have degenerated into tenements. The minute squares with stalls of brilliantly coloured fruit and vegetables contrast dramatically with the buildings washed in pale yellow, pink or cream, and across the small alleyways, long lines of washing flutter gently from the high buildings as they do in Naples.

Although most of the people speak French, they speak it with a strong southern accent and many even use the local dialect which boasts a number of folk songs. The people of Nice grasp any opportunity to celebrate in the form of processions, of bands or displays of regional costumes.

Naturally enough in such a picturesque quarter, there are plenty of old-world restaurants, patronised by tourists, charging rather high prices but serving excellent food, but there are also a number of genuinely old taverns, patronised mainly by the locals, serving regional dishes at reasonable prices. In such places as these, the menu is a simple one, but the wine is first-

class. The clientele will be a complete cross-section of society, and navvies and tramps and professional people join together, singing or reciting poetry.

There are one or two very good cafés and restaurants by the vast flower market which is one of the greatest attractions of Nice. It is held in a wide street that stretches between the sea and the old town but it is separated from the beach by broad terraces and this was originally the parade used by the Niçois on summer evenings whilst they strolled along watching the sunset over the sea.

The best time to see the market is early in the afternoon, for it does not begin to function until about 1.30 and by three or four o'clock, many of the stall holders have sold out and they begin to wander away. Here every conceivable flower is displayed in profusion with miraculous taste and protected from the fierce sun which finds a way in despite the vast, sheltering roof, the white and coloured umbrellas and awnings. Roses, carnations and lilies take the first place, but pot plants and palms and ferns and all the variety of everlasting, dried flowers, are so expertly presented that it is extremely hard to pass them by. These smiling, dark haired and often beautiful flower-sellers seem to have an absolute genius for giving variety to white flowers.

Most of the shops in the flanking streets are engaged in packing and despatching orders for flowers, but there are also several restaurants which serve good simple menus at reasonable prices and there are cafés where you can sit with a drink and watch all the colour and movement in comfort. Then, of course you will miss all the entertaining chat of the flower-sellers.

The Avenue de la Victoire is entirely different in character from the old town and it leads from the station to the Place Masséna near the front. It is more solemn than the Canebière at Marseilles but it is thronged with shoppers and window shoppers, and the café terraces are crowded with people who

come to drink, to watch or just to talk and gesticulate. The main centre of the town remains the Place Masséna. With its large, pink stucco houses it retains the nostalgic atmosphere of the early nineteenth century when it was built, and this is emphasised by the gardens which stretch down from it to the sea front, planted with the rather straggling palm trees common to all Mediterranean resorts. In this area there is a vast choice of popular restaurants and cafés which are not as expensive, but of course have not the view of those along the front.

Even a few yards along a street running up from the front, restaurant prices drop sharply. This is natural enough, since the broad terraces along the promenade with more or less luxury amenities have to be paid for, so that a cup of coffee is bound to cost more than elsewhere. Even so, there are places which serve copious *plats du jour* which is usually ample for Anglo-Saxon needs.

Many snack bars can be found just behind the Promenade des Anglais where a snack can mean a complete dish at a table. I was particularly impressed by the excellent food at a restaurant about fifty yards up the rue Meyerbeer, by the Hôtel Westminster, which had a choice of three *Prix-Fixe* and was always full of interesting cheerful people. One evening it was half occupied by the most lively and friendly Japanese. Since tourists do not frequent this part in any numbers, it is in the little bars that you may come across and make friends with entertaining local characters, who stand up at the *zinc* to drink their *pastis*.

Although Nice is so up-to-date as a resort, it is actually a place of antiquity. It was first heard of as a Greek colony and was one of the semi-independent states that were always being over-run or occupied by stronger neighbours. For some centuries it was under the power of the Counts of Provence until it came into the hands of the Dukes of Savoy. In 1859, it was ceded with Savoy to Napoleon III as a reward for his help in freeing the north of Italy from the Austrians. This was done

after an overwhelming majority of the Niçois voted in favour of being annexed to France. Even though the Niçois spoke a dialect of Italian, their choice was not altogether surprising, since culturally Nice has always been under French influence and French had always been the language of the educated people. Although the Fascists clamoured so insistently for the return of Nice to Italy, there has never been any enthusiasm for this by the people themselves.

Nice itself possesses the splendid Musée Masséna on the Promenade des Anglais which is housed in the palace built in 1900 by the Prince of Essling, grandson of Marshal Masséna. It contains some very fine Empire rooms which keep their original furniture and are often used for important official functions. The paintings are mainly displayed in the upper rooms.

A fifteenth-century wooden Crucifix of Italian influence has the sympathetic handling of nearly all carvings of this date, and a very much earlier seated Madonna, probably of the fourteenth century, is even more effective, possibly because there is no colour, only the beautiful, pale wood.

The Italian and French primitives are of great interest especially those of the School of Nice. There are two fine examples from Lucéram, north-east of Nice, a village I shall be describing later. The *Saint Margaret*, with the familiar school-of-Bréa deep scarlet robe, may be the work of Louis Bréa himself but the altarpiece of *St John the Baptist* is reliably attributed to Jacques Durandi whose painting of *St Margaret* we saw in Fréjus cathedral. The predella is particularly lovely.

A fifteenth-century *Crucifixion* from the school of Avignon strongly outlined against a gold background and an altarpiece of *St Michael* by an unknown fifteenth-century painter all merit close attention. A room of Impressionist paintings has some good Renoirs, Sisleys and Monets, but also includes works by Boudin, Degas and Dufy.

St Jeannet and Le Baou

The prints and water colours of old Nice are fascinating and so is the collection of silver fish, votive offerings from the local fishermen. They are very simple, but extremely effective; flat with naïve engraved details.

The Musée Chéret is a much smaller, less important, gallery in the Avenue des Baumettes, and is mainly concerned with displaying the works of the Van Loos, the family of Dutch painters who were mentioned earlier in connection with Aix. There is also a collection of modern French masters, including Braque and Matisse. You can study the history of the Nice Carnival here, if you want to—it is far too well-known to have any place in this book—and see the works of a number of indifferent nineteenth-century painters as well as some by Ziem. There are a few pictures by Marie Bashkirtseff, including a self-portrait. She came to Nice as a small girl and lived on the Promenade des Anglais. Her memoirs, written in French, give a delightfully vivid picture of Europe of the eighties. When she was only 13, Marie was passionately in love with a Scottish Duke, and she used to watch from her bedroom window to see him drive by in his phaeton on his way to a pigeon shoot, or to the splendid house of his mistress. She knew all about this affair but it did not shake her faith in him. Although she was so passionately devoted to her dear Duke, she was also extremely intelligent and most observant, and the impressions she recorded are of exceptional interest.

The suburb of Cimiez, to the north of the City, is quickly and easily reached. It was once the main residential quarter of the town, and here you will find the ruins of the Roman amphitheatre close beside the Hôtel Excelsior. Further down the Avenue du Monastère stands a monastery, re-built into the elaborate style of the 1860's, but the main interest is in the interior where there are three altarpieces by the Bréas. They provide continued interest in this school about which we have so little definite information beyond the works produced.

We do know that the Pietà here is Louis (or Ludovico)

Bréa's first altarpiece, dated 1475. The central panel depicts *The Virgin*, sorrowing over the dead Christ whose body lies on her knees, whilst angels hover over and around a large cross set against a distant landscape. In the panel to the right, *St Catherine* stands with her wheel and, to the left, *St Martin* offers his gorgeous cloak to a beggar seated on a splendid white horse with deep scarlet caparisons—a colour introduced into other parts of the painting and, indeed, almost a Bréa trade mark for it is deeper than scarlet, something like the darker geranium flowers.

It is interesting to compare this with this painter's last known work of 1512—a *Crucifixion*—and also in this church. It is less 'Gothic' and Flemish; that is, it reveals less of the International Gothic style reminiscent of illuminated manuscripts and the precise intricate detail of the early Flemish art, and is more definitely under the softer, gentler Italian manner, though the sombre colours, apart from the reds, are generally ascribed to Spanish influence. On no account miss the predella which is more lovely than the painting, as is often the case since, in these small scenes, the artist was more free to paint what delighted *him* rather than his patron.

There is also a fascinating predella in the *Descent from the Cross* painted by Louis' brother Antoine.

The Museum of local archaeological finds also contains, on the first floor, the Musée Matisse and has a reasonably representative collection of the artist's work including paintings, drawings, sculpture and ceramics.

Matisse painted a joyous poster for Nice which contained the words: '*Nice, Travail et Joie*'; the reaction of a man who knew the town well. He arrived in Nice in December of 1916, an inauspicious moment since the Riviera was undergoing a long spell of rain. He had to stay in his hotel room for days and was reduced, so he said, to painting with his umbrella propped up in the slop-pail when he worked on his balcony. It was too much. He decided to leave, but then the sun came

out and transformed his world, so he stayed, he painted, he remained for most of the rest of his life and was made a Freeman of the city. To begin with, he lived in an hotel, then he rented a studio close to the old town and, just before the Second World War, he bought a flat on the third floor of the Hôtel Regina, then a luxury hotel amidst palm trees in Cimiez, with a view in fine weather right across the Mediterranean to Corsica.

Matisse lies buried in the cemetery at Cimiez, where Dufy is also interred. Cimiez is really part of Nice, but with the constant surge of traffic along the whole of the coast, and built-up areas between the resorts, Nice is now linked with many other places—Cagnes-sur-Mer, Antibes and Cannes—which used to have separate identities.

When driving along the waterfront, it is difficult to distinguish where one place ends and another begins, but this is not true of the hinterland, for within a few miles of the coast, even the tourist-ridden 'picture' villages are completely separated from each other by winding roads in completely rural surroundings.

From Nice there are endless places of this type to explore, as well as villages which are little visited. For the most part of the year there will be scarcely any traffic once clear of the waterfront. A mile or so beyond Cagnes where the motor road proper now begins, a road leads inland to Biot, a picturesque village, 'spoilt' in a way, but fascinating even so, with its winding cobbled streets, its arcades, its bohemian life and two outstanding monuments—the Fernand Léger Museum and the church with remarkable altarpieces.

Since the museum is just outside the village and is unique in that it is the only museum in France to be entirely devoted to the work of one painter, I will deal with that first.

This arresting building is set on the slopes of a hill, in a typical Provençal landscape of cypresses, olives and pines. A conventional iron entrance gate opens onto smooth green lawns

which sweep uphill to the museum with its brilliantly-coloured ceramic façade. Indeed the whole structure was designed by André Svetchine, a well-known Nice architect, to embody this mosaic, originally commissioned for the Olympic Stadium at Hanover—hence its theme of sport—and also to incorporate the great stained glass window in the entrance hall.

Fernand Léger, in company with Picasso and Braque, was one of the first Cubists and he worked both in Paris and in Biot where he encouraged the ceramic industry in much the same way as Picasso encouraged it in Vallauris. The main difference was that Biot has always produced simple pottery of good shape for everyday use—and taste cannot go far wrong if no colour or decoration is employed and the objects are utilitarian. Biot had a long tradition of producing the huge jars used in Riviera gardens and filled with tropical plants and geraniums. Vallauris was far more ambitious and had more scope for bad design before Picasso stepped in.

Léger's paintings and ceramics are superbly presented against plain pale walls and lighted by vast windows. The early works, which are a kind of hymn to the machine and industrial age, are on the ground floor, and his later more sympathetic paintings of characters enjoying themselves, cycling, dancing and picknicking, are on the upper floor.

Some of Léger's early works seem rather harsh and un-compromising in their matter-of-fact statements, but the colour is always glorious and often unusual; the sense of design and the simplification of form makes them works of art of the highest quality. His later pictures of acrobats in fantastic poses, are full of gaiety, especially *La Grande Parade*, carried out in black and white on a soft crimson background. Some of his later paintings are distinguished by dusky brown, indigo, silver and black with touches of brilliant scarlet, green and yellow. Léger himself wrote : 'We are taking part in a dangerous and magnificent epoch.' He was living it to the full and making his own contribution to modern art, a contribution which can be

summed up in his own words, loosely translated : 'A painter
should not attempt to reproduce beautiful objects, but to paint
in such a way as to make his picture a beautiful object in
itself. . . . Beauty is everywhere : in the arrangement of your
cooking pots against the white wall of your kitchen. The sub-
ject is not the principal person, it is the object which replaces it.'

We can take a great leap back over the centuries if we climb
through the medieval streets of stone houses with beflowered
balconies to the arcaded square and go into the church at the
far end to see two altarpieces of the fifteenth century. Here
a *minuterie* makes up for the lack of daylight so that the paint-
ings can be seen clearly. Of these, a polytych of *The Virgin of
Mercy* is probably the work of Louis Bréa. The Virgin in the
centre panel wears a robe of gold damask and holds the Infant
Christ on her left arm, while she clasps a rosary of scarlet
beads in her right hand. Angels bear the train of her mantle
and the Emperor, in black robes, kneels at her feet. Mary
Magdalene and St Bartholomew are represented on side panels,
kneeling to the Virgin.

The second painting is the *Passion of Christ* by an unknown
fifteenth-century artist. Christ stands, filling the whole panel,
holding the cross and with the emblems of the passion around
Him, whilst winged angels hold a brocade cloak behind His
shoulders.

We lunched at a restaurant in the square, on the pavement
beneath the arcades, and had a splendid gala Sunday meal.
The wide variety of pâté and other cold meats produced as
hors d'oeuvres was a full meal in itself, so was the jugged hare
and the board of a dozen cheeses. Fresh, crunchy loaves of
bread, a large slab of farm butter and a bowl of fruit and a
bottle of wine completed a menu which cost under thirty
shillings. We could have fed here for a good deal less on a
weekday, but Sunday midday, being a rather special meal,
naturally costs rather more. The restaurant was crowded with
vivacious friendly people, all enjoying a lunch which was

virtually *en famille*, since we were all seated close together and there was a set menu with no basic choice.

From Biot it is quite feasible to pick a way across country to Grasse but I like to keep this lovely town as a highlight on the journey back to Avignon or to the channel, as it is the obvious route when you have had enough of the coast.

There is also a whole group of places much nearer Nice which no one would wish to miss, even though they are 'dolled up'; any one of them could serve as a centre for seeing the others. The most obvious of these are Haut de Cagnes, St Paul, Vence and St Jeannet; a turning just outside Nice leads to all of them.

Cagnes is really three villages, but if we discount the brash Cros-de-Cagnes on the sea front, we turn into the main village of Cagnes-sur-Mer. This does not offer very much of interest save a few old streets and the fact that it serves as a route to Renoir's house on the slopes of an olive-clad hill; it is the old fortified stronghold of Haut de Cagnes which lies beyond, which is really of interest.

Renoir came to the region early in the century. He had for some years been suffering from rheumatism and from the early eighties he spent more and more time in the south, trying to find a climate which might alleviate his trouble. Eventually he settled at Les Collettes near Cagnes after living in various places in the district. By now arthritis had set in and nothing could check its increasing grip. He was soon reduced to getting about on crutches and, by 1912, he had to take to a wheeled chair. Nothing daunted this magnificent old man, nothing could prevent him from working, not even the death of his wife. He knew there was no hope of recovery, that he would be more and more paralysed, but he insisted on continuing to paint and had his brush strapped to his twisted hand. Every day, despite increasing years and the painful and crippling arthritis from which he suffered, Renoir painted: the light, the olive trees, the sky, the roses. It was perfect inspiration for

such a painter who always chose to depict the charming, gay, enjoyable side of life.

Despite great physical difficulties, Renoir produced a large number of canvases during the last years of his life, and from all accounts, he was an exceptionally pleasant character, full of kindness and sympathy and deep affection for his family. When he died, after pneumonia followed by a heart attack in December 1919, his two younger sons were at his bedside, but his eldest son, Pierre, was not able to reach Cagnes in time to see his father.

Félix Fenéon, who though a supporter of the Impressionists often criticised Renoir's work, wrote that in death 'in his first floor room at the Villa des Collettes with its windows wide open to the trees and to the sea, he lay on a bed covered with his favourite flowers : roses—tea roses and pink roses. . . .'

He was buried in the family vault at Estoyes in 1919. Elie Faure wrote the moving epitaph :

'It is as though the sun had gone out of the sky.'

Cagnes may be an over-picturesque medieval hill town but, even so, it is a very lovely place and a reasonable amount of tidying up and modernising does mean that once untouched and unhygienic places become fit to stay in and to eat in. Usually the sophisticated and often intellectual people who remodel them, create a friendly stimulating atmosphere and the bars and restaurants and cobbled streets are only tourist-ridden for part of the day and a few months a year. Haut de Cagnes is very gay, with flowers everywhere and there is a surprising variety of hotels and bars, some of them quite inexpensive.

The Chateau Musée, housed in the medieval castle which was partly transformed in the early seventeenth century, contains models of historical and regional interest as well as paintings by modern Mediterranean artists including some by Chagall.

Nearly every house is a studio and geraniums and bougainvillaea overflow from windows which look on a distant landscape of olives, orange trees and the sea, all made miraculous by the radiant light which kept Renoir in Cagnes for the last thirteen years of his life.

Completely surrounded by ramparts, Haut de Cagnes is typical of the dozens of 'eagle nest' fortress towns to be found in more or less their original state along the Mediterranean complete with a castle built to watch for pirates and as a refuge for the people from the lower town.

The fourteenth-century chapel of Notre Dame de Protection has some good sixteenth-century frescoes in the Apse.

Cagnes set the pace for sophistication for a whole number of hill towns lying nearby. Painters and writers flocked to St Paul de Vence after the First World War and took over the ancient village which Francis I had surrounded with ramparts in the sixteenth century, destroying a large number of houses on the perimeter. Nevertheless the narrow streets and alleys climb and twist between old houses transformed into habitable comfort and near a twelfth-century 'keep' stands the church which was built a little later but restored in the seventeenth century.

At the entrance to the village, La Colombe d'Or, a very special hotel producing very special meals, possesses one of the finest private collections of modern art in France. It is an extraordinary sensation to be at a bar, ordering a drink, and to look round the walls and realise that there are literally millions of francs' worth of paintings hanging there. Over the course of the years, the proprietor has been given, sometimes in lieu of payment, paintings by artists who came to this famous restaurant. They include such names as Chagall, Bonnard, Picasso, Vlaminck and Miro. You too can see them if your pockets are sufficiently well lined to pay for a really superb meal, though the bar may not be open to the casual visitor now that this collection has become so well-known.

This essentially twentieth-century atmosphere is in marked contrast to the atmosphere of the church where the main interest is in the interior. You will find good altarpieces, though they are not by outstanding masters, but a painting of *St Catherine* is almost certainly partly the work of Tintoretto and, in the treasury, there is a superb thirteenth-century *Madonna and Child*, which could equally well be Romanesque or modern in its stark power, silver and alabaster and enamel statues, reliquaries and crosses.

I have only been to St Paul in the early spring or late autumn, so I cannot tell to what extent throngs of visitors spoil it, but out of season it is certainly a delight to stroll through, up and down more or less deserted streets; cobbled streets of beautiful houses of a great variety of styles and, above all, one of the most lovely of the non-monumental fountains in Provence. This beautiful urn-shaped fountain splashing into a round basin and set between two arched entrances beneath a terrace overhung with brilliant flowers, never palls in its serene perfection.

Until about fifty years ago, the shops opened directly onto the street and were windowless, but even now with discreet modernisation, it is possible to discern the medieval stall with the little room at the back where a craftsman would make the goods he sold.

Many of the houses have some distinctive architectural features such as a stone coat-of-arms over their portals or massive stairways at the back of a shadowed courtyard. Needless to say, the arty-crafty have opened up shops where handmade pottery, souvenirs, pictures and 'chunky' jewellery are on sale, but there are also goods that are really lovely and worth investing in. Bars and taverns with a skilfully created artistic atmosphere can be quite entertaining, but we usually content ourselves by chatting with the local postman at the Café-tabac where excellent wine is served by the glass.

A museum, which is perhaps the most modern of any in

Europe, lies on the nearby hillside. The Maeght Foundation which first opened its doors in 1964, lies spread out over the slopes of les Gardettes and is a kind of architectural ensemble of pavilions, terraces, arbours and open country as background and setting for modern art.

Even the most conventionally minded cannot but be impressed by this fantastic achievement of our times, though they may not be in sympathy with much of the work displayed.

The area is entered through a portal of black girders between lawns; on one side stands an old Romanesque chapel and, on the other, a most exciting arrangement of bright metal piping by the German sculptor, Norbert Kricke which I can best describe as a rhythmic tree dancing a ballet. The Romanesque chapel has been most successfully modified as partly ancient and partly modern. Early Christian bas-reliefs, an ancient wooden Christ and very modern Stations of the Cross in black stone or slate make a perfect marriage of styles, and all are lit by a glorious modern stained glass window in violet and blue-green with the outline of the dove of peace left in clear, thick glass. A Bronze by Barbara Hepworth is doubly effective against the grass and a figure by Jean Arp is set in a circle of trees.

Some of the great carvings are perhaps rather too basic to be really satisfying, but nearly all of them do have tremendous impact and power. The huge monolithic shape on the crest of a rise, with its giant pitchfork, is wildly exciting against the sky.

Mobiles painted in primary colours are a little redolent of a fun fair, but set out on wide terraces they do give a feeling of space and movement and those of shining metal flicker and shimmer against the trees in a fascinating way.

Five rooms in the museum building are devoted to the works of Braque, Kandinsky, Chagall, Miró, and Giacometti, and Bonnard, Matisse, Léger and the Ecole de Paris are all well represented.

The collection is constantly being enlarged and the rooms rearranged and kept up to date, but among the most exciting exhibits at the moment, are the two huge butterfly tapestries by Matisse in the entrance hall, in a brilliant cadence of pale blue, white and deep blue.

Vence, only three miles away by a rather steep road, also has the inevitable colony of painters. Like Cagnes, it is com-

posed of three towns—the nineteenth-century town on the same level as the walled city adjacent to it, then a new suburb of villas, pension and nursing homes.

Old Vence has been a fortress since pre-Norman times and was occupied in turn by Phoenicians, Greeks and Gauls and besieged by Saracens and Lombards.

Oddly enough, although the town was a See until the Revolution, the Cathedral—now a parish church—is not of any great interest although the Gothic choir stalls are carved with great imagination.

The northern half of the ramparts is still intact, including

the gates and tower of a castle. The Place Peyra is a wide square shaded by a large tree, with a graceful fountain, much like the one at St Paul, trickling gently in a corner. Fortunately for Vence, artistic invaders have not completely swamped the local inhabitants, and in some of the narrower streets, original craftsmen have survived and continue to make their platters of fine wood.

In the Gallerie 'Les Arts' there is a good collection of works by Chagall, Dufy, Segonzac, Vlaminck, Van Dongen and many other painters of the period.

D. H. Lawrence was among the many celebrities who spent part of their life in Vence. He came here in the last stages of tuberculosis in 1929 and died of it, at the age of 45.

Matisse, too, sought health in Vence, and although not a Catholic, he built a chapel for the nuns who nursed him. Set on the hillside a mile or so beyond the town, it is a simple shining white building with a tiled roof surmounted by a wrought iron cross. The narrow, stained glass windows are blue and yellow and, above them, and over the entrance, are set decorated tiles.

In the interior, the clear southern light is reflected from the white walls and the three large panels of painted tiles; the floor is tiled and the simple wooden altar stands on a slightly raised platform beneath the stained glass windows. The whole effect is of a wonderful harmony of blue, yellow and white emphasised by the strong black lines of the drawings on the tiled panels.

As a relaxation from all these manifestations of the arts, there is a very pleasant road northwards to St Jeannet which stands more than a thousand feet above the sea in the shelter of a great peak of rock—le Baou. Although many people have come to live here among the olives and the vines, it has not become a Bohemian colony and is not inundated with tourists, consequently it does not have the same variety of restaurants and bars as the more sophisticated places to the south.

There is a route back to Nice from here more or less parallel to the waters of the Var which runs through St Laurent. At St Laurent, there is a roadside restaurant which does not look exciting from outside as a huge gravel parking place for lorries gives it the appearance of a pull-up, but it is in reality a most pleasant, welcoming inn with tables set out in a garden—a real southern garden with olive trees and geraniums in huge earthenware jars, a line of washing slung between two eucalyptus trees and sunflower heads drying in the sun. Cats and a big shaggy dog basked in the sun when we were there, and exotic coloured birds sang in an aviary. The food was regional, very good and moderately priced. This must have been a wonderful place to stay en pension before development brought the main highways too near.

XII

THE COUNTY OF NICE AND THE
ROUTE NAPOLEON

The corniches – La Turbie – Roquebrune – Menton –
The small towns of the hinterland – Sospel – Lucéram
– Utelle – The Vallée des Merveilles – Tende –
Villefranche – Cap Ferrat – Eze – Entrevaux – Annot
– Grasse – Bar-sur-Loup – Digne – Sisteron

EASTWARDS from Nice, three corniches run roughly parallel
to the coast. The lower twists in and out of the fishing
villages, the middle goes along the heights with resultant
widespread views and the upper makes a good many swerves
inland.

The Upper or Grande Corniche was constructed by
Napoleon in 1806 over the former Aurelian Way which went
from Rome to Arles via Nice. Its height above the sea gives
the most extensive views as far as Italy, Monte Carlo, Cap
Ferrat and even, at times, as far as Corsica. This is now of
course a wide road which carries a heavy load of traffic, but
it does lead to La Turbie, to Roquebrune and to Menton.

The majestic Roman monument of La Turbie was erected in the year 6 B.C. to commemorate the victories of Augustus over the tribesmen of the Alps. It was so huge that although much of it was used later as building material, there is still a fair amount of it intact, but the two white columns at the top are restorations.

The village of Roquebrune, further along the coast with its castle which dates back to the tenth century, has streets which are arcaded, and one even dives under buildings and through the face of the rock.

Beyond Roquebrune the road drops south cutting across the neck of Cap Martin to Menton.

Now in my opinion Menton has dropped sharply in attraction during recent years and has none of the gaiety and liveliness of other large towns on the coast. The rather dilapidated shell of its nineteenth- and early twentieth-century splendour remains however, and the curious old town with its maze of twisting streets and stairways has a rather gloomy appeal.

The new town is the result of the fact that the superb climate of Menton drew thousands of English and others from colder regions, to winter here, so there are dozens of hotels with English names; there are beautiful gardens of exotic plants, a Casino which still enchants with its fantastic decorations, and of course the colourful lemon festival which so delighted our grandfathers, transforms the whole place in February.

The old town also has its monumental aspect reached by a double staircase paved with black and white pebbles, known as the Rampes.

There is nothing of outstanding interest to see, though the Italianate architecture does offer a lovely skyline of belfries and towers rising out of the tiers of whitewashed houses.

The double square, linked by steps, with its two churches with fine Baroque façades, provides a lovely setting for the Festival of Chamber Music held in August and lighted by thousands of torches.

The Town Hall which has a museum of pottery, pastels and tapestries also provides a stage setting for weddings, for Jean Cocteau has decorated 'la Salle des Mariages' with allegorical frescoes.

The scenery of the hinterland of the Grande Corniche, served by secondary roads, is varied and beautiful, for the Mediterranean vegetation is at its best here and many of the old towns and villages are entirely unspoilt and away from the main highways, but it is necessary to have a good large-scale map to find them.

St Agnes is a pretty place with some vaulted streets a few miles inland and Peille, further north-west, is a typical fortified village which at present has not been over-run. It has the usual vaulted, climbing streets, a charming square with Gothic arcades and a fountain. The church, above the village, has a Romanesque and Gothic nave.

Peillon, nearer the coast, is also a lovely place but there are a dozen others to be explored on foot or by car and I have only space to mention a few here.

Of the more important places as regards sightseeing, Sospel lies fourteen miles inland and is reached by a very winding road. It has some arcaded houses and a medieval twin-arched bridge spanning the river Bévéra which runs through the village. The huge seventeenth-century cathedral, restored in the eighteenth century, contains an altarpiece of *The Immaculate Virgin* by Francois Bréa. At Lucéram, further north and nearer Nice, you will find three more very good examples of the work of this school.

I am not suggesting that anyone but the specialist will want to follow up all these indications of where the works of the School of Nice are to be found, but it may be useful to know of those within reach of any individual itinerary. Indeed I must admit that, lovely as many of them are, they do tend to be repetitive, and when you have seen a few good examples, you have, in a sense, seen them all.

The thirteenth-century church at Lucéram, all but completely submerged under Italian stucco in the eighteenth century, contains five altarpieces of the School of Bréa, three of them possibly by Louis himself although several of the altarpieces already described in the Masséna at Nice came from here. Particularly worthy of attention are the *St Anthony* and the ten-panelled *Ste Marguerite* behind the High Altar. As well as these lovely altarpieces, there are two Pietàs in the nave, one of the thirteenth century and one of the sixteenth. The treasury contains a fifteenth-century copper and silver statuette of *Ste Marguerite*, a monstrance, a reliquary and a sixteenth-century alabaster *Madonna*. In the choir are some most decorative old processional wrought iron lanterns.

If you add to all this, the fact that Lucéram, still surrounded by towered battlements, makes a wonderful silhouette of pink roofs and a graceful campanile against the terraced hill-side, it is well worth making a deviation to see it.

Utelle, further to the north-west and almost directly north of Nice, is reached through wonderful countryside and there is a miraculous panorama from the sanctuary of the Madonna above the nearby village of St Jean la Rivière. The church at Utelle has a beautifully carved wooden door beneath a Gothic portal and contains a sixteenth-century altarpiece of the *Annunciation* by an unknown artist. The painting is moving in its simplicity and in the naïvety of the landscape seen through arched openings which replace the more usual gold background. The simple predella depicts Christ rising from the tomb with saints on either side.

Venturing much further north-east beyond Sospel, a good road runs to Tende, but before reaching the town a smaller one crosses it which leads to points of interest in each direction. Eastwards, La Brigue, a little over a mile away, has a Romanesque church with a Lombard tower and more primitives, including the, by now, inevitable Louis Bréa, but three miles beyond, the Chapel of Notre Dame-des-Fontaines, set in the

beautiful Lavanza valley, contains some unusual and very lovely frescoes mostly by Jean Canavesio, but if you wish to see them, you must first collect the keys from the Presbytery at La Brigue.

Jean Canavesio, presumably an Italian working at the end of the fifteenth century, has taken as his subject the Life of Christ and he depicts here its principle episodes with the utmost skill in composition, with a touching realism and attention to detail. *The Last Judgement* and *The Crucifixion* are perhaps the most beautiful of these wonderfully preserved, richly coloured frescoes, and the macabre *Hanging of Judas* is the most vivid.

The road leading west from St Dalmas-de-Tende comes to an end at Les Mesques, but from here you can follow the Vallée de la Minière on foot through a region of small lakes dominated by Mont Bego. Along the slopes of this mountain, and on the slopes opposite, some 35,000 signs and modified figures of animals and humans have been traced, probably by prehistoric men from the valleys going on pilgrimages to the heights. This can be an arduous trek, but it is an unique experience in a strange region with the aura of great antiquity. As I wrote in an earlier chapter, these curious markings have no real artistic value; they show none of the pictorial or dramatic qualities of the prehistoric paintings at Lascaux or at Altamira, nor any of the instinctive feeling for rhythm and decoration of the Iron Age scrolls and spirals decorating standing stones in Ireland and elsewhere.

Tende itself is much like any other of these hill towns, but the church has an unusual and lovely Renaissance portal flanked by columns supported on lions and, in place of an elaborately decorated tympanum, Christ, with the apostles on either side, is rather stiffly presented on the deep lintel.

The whole region, stretching from the coast for some miles inland and eastwards to the Italian frontier, is inexhaustible, for there are literally hundreds of villages and minor roads to

explore on foot or by car, over and above the obvious places with monuments of great interest. There are also places on the middle and lower Corniches which, though they are of course crowded for much of the year, are well worth seeing.

The middle Corniche was built to divert some of the traffic from the coast road and it provides panoramic views of the capes and inlets of the rocky shore. It also leads to the fortified village of Eze perched high on a rocky pinnacle and basically a perfect relic of the Middle Ages, but completely over-run.

The inhabitants of the fishing ports along this coast were not at all pleased when the lower corniche reached them in 1862. They were still fearful of pirate invasions although these were rare in the nineteenth century.

Villefranche lies just round the corner of the headland east of Nice, and since motor traffic cannot penetrate the streets which wind uphill from the coast, it is relatively unspoilt. Do not be put off by the seething traffic of the upper highway which views it through a cluttered suburb and sees nothing of the old town and harbour.

Villefranche is certainly not the unsophisticated place it was half a century ago, but it has preserved most of its former charm. Steep narrow streets go down to the harbour where yachts and fishing boats are moored. On the stone wharves, there are cafés and restaurants with terraces from which the gaily clad visitors watch the fishermen spreading their russet nets.

Down by the harbour, a medieval chapel which for years was used by local fishermen as a net shed, has been restored and decorated as a fisherman's chapel by John Cocteau. This does not claim to be a really great work of art such as Picasso's *War and Peace*, but it is a satisfying and delightful decoration, admirably suited to its purpose and with an appeal to everyone. The soft cool pastel greens and blues and cream, the sinuous outlining of the characters and the general rhythmic flow of the design in a superb stage set. The decoration of the

pillars and arches is geometric—a network of line directing attention to the subjects illustrated. With themes from the Life of Christ, Cocteau introduces characters from the region, even including gypsies from Les Saintes Maries. It is indeed a homage to the fishermen. Jean Cocteau himself writes : 'I offer this work . . . to the fishermen of Villefranche, of Beaulieu and of St Jean.'

Before leaving Villefranche, do not fail to visit the strange galleried side streets built right under the solid mass of houses on the slope which continues behind the town to a height of nearly three thousand feet.

The long green spit of St Jean Cap Ferrat lunges far out into the sea to the east of Villefranche to form an almost landlocked bay. On the promontory there are several large hotels and many luxurious ones, for this is one of the few parts of the Riviera which has remained exclusive as well as fashionable. Here Somerset Maugham lived for years and died at la Mauresque. On the neck of the promontory stands the astonishing building of the Fondation Ephrussi-de-Rothschild, for some reason called the *Musée 'Ile de France'*.

One day when Madame Beatrice Ephrussi, who was born a Rothschild, was walking amidst the luxuriant vegetation on the western side of the peninsula, she found what she considered the ideal spot, 'the most beautiful scene in the world'. She bought the land, had it levelled and built an amusingly ornate house. It was different from any other house in that it was designed to take individual works of art. For instance, a ceiling was specially constructed to take a Tiepolo painting, a wall was pierced to incorporate a Renaissance doorway. The general background is perhaps too lavish and the display too abundant but, amongst this superabundance, are some great treasures of the Middle Ages, of the Italian Renaissance, of fine furniture, of Gobelins tapestry and of seventeenth and eighteenth-century paintings. The specialist will want to wander around the rooms at leisure and seek out the really

outstanding exhibits which are not necessarily very obviously displayed.

The gardens are a separate feature of this remarkable foundation and comprise not only the formal French garden which sweeps into the distance with its great bed of giant salvias, its fountains and terraces, but English, Spanish, Florentine and Persian gardens and, beloved of the southerner, a garden of exotic plants.

After climbing the rising ground at the neck of Cap Ferrat, the road descends once more to Beaulieu, a resort reputed to have the mildest climate on the whole of this coast, and certainly cactus, prickly pear, bougainvillaea, palms and lemon trees grow in the greatest profusion.

The coast road continues through the lower village of Eze to Monte Carlo, four miles to the east.

The approach to the principality is completely spoilt by arterial roads, built-up ugly suburbs and a heavy load of traffic. It is outside the scope of this book, but it is of interest to note that apart from its obvious scenic, sightseeing and gambling attractions, there is a most magnificent aquarium of rare and strange creatures.

From Nice I always like to take the route back home through Grasse and spend my last nights in the south in this enchanging town, continuing through Castellane and Digne and on through devious roads to Avignon, but of course there are a dozen variations.

One part-alternative is to take the road through Entrevaux which meets the road from Grasse at Barrême, north-west of Castellane.

The small fortified town of Entrevaux has become increasingly frequented by trippers from Nice, Cannes and Monte Carlo, so the best time to come here is in the early morning or in the late afternoon when the coaches have gone.

In the past, the town was of great strategic importance for, whilst it remained untaken, an invading army could advance

no further up the valley. It was only accessible by a narrow bridge; huge ramparts encircle it and a forbidding citadel commands the approach from both directions.

A little beyond Entrevaux a road winds along the Gorges de Daluis where melodramatic effects are contributed by the waters of the Var which flow between the cliffs of dark red rocks.

West of Entrevaux I can never resist turning off north for a short distance to Annot, a town on the swiftly flowing trout stream of the Vaire. The new town is on level ground with a main street which straggles through a large shady square facing the riverside meadows and wooded hills. The old town climbs up the sides of a small eminence and is one of the most typically Provençal cities of the region. A tangle of narrow streets bridged in places by graceful round arches converge eventually on two adjoining squares. The simple church is a mixture of Renaissance and Romanesque styles and seems always to be filled with people assisting at a funeral, a wedding or a feast day. On the exterior, is suspended a huge wooden cross surmounted by a large bronze cock crowing to announce the Resurrection.

There are no luxury hotels at Annot, but the three or four comfortable inns do sometimes serve freshly-caught river trout and an infinite variety of mushrooms served in different ways.

The climate here is usually good except in the depth of winter and there is plenty of sunshine. There are wild boar and chamois, but they are getting increasingly scarce and can only be glimpsed with patience and good fortune, but the walks up through the steeply rising meadows to the rocky pine-clad heights are a reward in themselves.

Grasse is reached from Nice or Cannes by a road which climbs steadily up through typical Mediterranean scenery to a height of over a thousand feet to the slopes where there are fields of flowers and large groves of orange trees. The town lies at the foot of a range of mountains that protect it from cold

north winds and, since it faces due south, the climate is mild and at the same time, quite bracing. As the air is usually clear, the view is extensive; first fields of flowers and orchards, then the tiered foothills, silvery green with olives and, in the far distance, the brilliant, gleaming blue sea.

Before the coming of the railways, Grasse was the first stage of the route that Napoleon followed in his historic march to recover his lost empire. The perils were such that most travellers preferred to go to Marseilles by boat and then north-ward to the capital by the Rhône Valley.

The lay-out of the town is extraordinarily effective. On the heights, the Cours Honoré Cresp, an enormous tree-shaded terrace with views to the sea, is the social centre of the town. At the far end of the *cours*, a narrow street, the rue Jean Ossola, leads into the old town. On the left, up the hill, is the lovely arcaded and shady Place des Aires with its simple, but graceful fountain. To the right, the Cathedral is very impres-sive in its Romanesque simplicity, particularly the extremely thick round columns of the interior. Two altarpieces are in marked contrast : one, *St Honorat with Six Saints*, is probably by Louis Bréa, and the other, almost pagan in its frivolous treatment, is a suave flowing composition of *The Washing of the Feet* by Fragonard who was more at home with a boudoir scene than a religious one.

The painter returned to Grasse, which was his native town, during the difficult years after the Terror. A few of his draw-ings and paintings are shown in the Musée Fragonard which also has regional costumes and furniture, as well as old prints of the town. The collection is housed in the Palace that once belonged to the Marquise de Cabria, sister of Mirabeau.

Although the greater part of the fortifications have disap-peared, many of the ancient streets have kept their former aspect. The old house where Fragonard spent his years of exile is in the rue Fragonard not far from the cathedral. The rue Droite, further on, was the principal street of Grasse in

the Middle Ages and a tablet marks the dwelling of Doriade
Roberti, perfumer to Catherine de Médicis, the Queen who
launched the scent industry in Grasse.

I must admit that there is real romance attached to the
making of these perfumes, for they are distilled from flowers
—flowers that are grown locally and add fragrance to the
countryside—a countryside which produces thousands of tons
of flowers every year : mimosa, jasmin, lavender, roses, orange

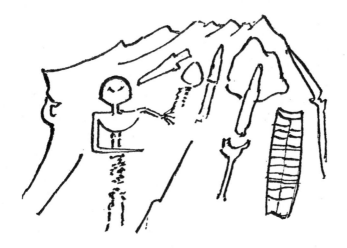

blossom, and violets. Small wonder that the streets have
romantic names such as the rue Sans Peur, the rue Réve-
Vielle, picturesque as they snake between the old stone houses
or rise and descend in flights of steps.

The village of Bar-sur-Loup is only a few miles to the east
of Grasse. The church has carved doors and a Bréa altarpiece,
but also, in marked contrast to the Italianate style of this
master, there is a remarkable *Danse Macabre*, by another
member of the School of Nice, painted on wood in the fifteenth
century in the popular realistic manner of fresco workers. This
strange picture is said to have been inspired by the legend that

a certain Comte de Bar gave a ball in Lent with the awful judgment that the guests all dropped dead in the middle of their revels. Death shoots arrows at the dancers and, as they die, their souls in the form of tiny little figures emerging from their mouths are weighed in the balance and hurled into the mouth of a monster representing Hell.

From Grasse a secondary roads runs through Draguignan direct back to Avignon, a route running north of Aix through countryside already described. The more northerly road, through Castellane and on to Digne, makes it possible to see both this last town and Sisteron before going south-west to Avignon and the train ferry or working a way through north-western France to the Channel.

The second way continues to follow the route Napoleon and passes through the once popular spa of Digne. This town is no longer very attractive, but it does have a pleasant, tree-shaded walk near the river, and the streets of the old city climb up to the Town Hall and on to the Market Square and a cathedral which has been so much restored as to be uninteresting.

The church of Notre Dame-du-Borg is a really lovely Romanesque basilica dating from the thirteenth century. The tower is twelfth-century and there are remains of a Carolingian structure at the base.

There is a choice here of going north to Sisteron or of dropping down to Peyruis and taking the opportunity of seeing the Benedictine Abbey of Ganagobie with its rare scalloped portal and its twelfth-century mosaics.

There are archaeological remains on the Ganagobie plateau —megalithic monuments, a small eighth-century basilica and the remains of Carolingian fortifications.

Sisteron is set at the foot of a rocky crag which seems to overshadow it. The greater part of the ramparts have disappeared, except for the round towers which stand at intervals like sentinels on guard. At the entrance to the town men play

endless games of bowls in a large lime-shaded square, but there are few sights, in the accepted sense of the word, apart from the twelfth-century cathedral which has a particularly lovely Lombard portal, and a beautiful cupola over the choir.

Sisteron is too far north to keep the southern atmosphere of Provence and so I would always rather make my last real halt in the warm, colourful Mediterranean streets of Grasse then drive by minor roads through the fascinating and varied scenery north of Aix, and along the Durance to Avignon.

APPENDIX

MUSEUMS AND MONUMENTS

AIX
Atelier Cézanne
 10–12, 2.30–5.30 p.m.; closed Monday.
Bibliothèque Méjanes
 9–12, 2–6 p.m.; closed Sunday, Monday.
Musée Granet
 9–12, 2–6 p.m. (5 p.m. winter); closed Tuesday.
Musée Paul-Arbaud
 10–12, 2–5 p.m.; closed Wednesday.
Musée du Vieil Aix
 10–12, 2–5 p.m. (4 p.m. winter); closed Monday.
Musée des Tapisseries
 10–12, 2–6 p.m. (2–5 p.m. winter); closed Monday.
Pavillon de Vendôme
 10–12, 2–5 p.m. (6 p.m. summer); closed Monday.

ANTIBES
Musée Grimaldi
 10–12, 3–6 p.m. (3–5 p.m. winter); closed during November
 and on Tuesday in winter.

AVIGNON
Musée Calvet
 9–12, 2–6 p.m. (2–5 p.m. winter); closed Tuesday.
Musée Lapidaire
 9–12, 2–6 p.m. (2–5 p.m. winter); closed Tuesday.
Palace of the Popes
 9–12, 2–4 p.m. (6 p.m. summer); guided visits only : every
 hour in winter, every half-hour in summer.
 Son et Lumière. 9.45 p.m. August 1st–September 30th.

ARLES
 A combined ticket (*global*) is available, at a considerable saving,
 to cover entrance to all museums.

8.30–12, 2–7 p.m. (2–5.30 autumn and spring; 2–4 p.m. winter).

BIOT
Musée Fernand Léger
10–12, 3–7 p.m. (2–5 p.m. winter).

CAGNES
Château-Musée
10–12, 2.30–6.30 p.m. (2–5 p.m. winter); closed Tuesday and October 15th–November 15th.

Musée Renoir
2.30–4.30 p.m. (2–5 p.m. summer); closed Tuesday and between October 15th and November 15th.

CARPENTRAS
All Museums
10–12, 2–6 p.m. (2–5 p.m. winter); closed Wednesday. Combined ticket available.

FRÉJUS
Baptistery and Cloisters
Ring for Custodian. 9–12, 2–6 p.m. (9.30–12, 2–4.30 p.m. winter); closed Tuesday.

GRASSE
Musée Fragonard
10–12, 2.30–6 p.m. (2–5 p.m. winter); closed Monday and month of November.

MARSEILLES
Most Museums open as follows : 9–12, 3–6 p.m. (2–5 p.m. winter); closed Friday morning and Tuesday.

Musée des Médailles
9–12, 3.30–4.30 p.m.; closed Tuesday and during August.

La Major
Guided visits between 8 a.m. and 6 p.m.

MENTON
Musée: painting, sculpture and local history
9–12, 3–6 p.m. (2–4 p.m. winter); closed Monday.

MONTMAJOUR
Abbey
9–12, 1.30–6.30 (1.30–4 p.m. winter); closed Tuesday.

NICE
Musée Chéret
 10–12. 2–5 p.m.; closed Monday.
Musée Masséna
 10–12, 2–6 p.m. (2–5 p.m. winter); closed Monday.
NICE-CIMIEZ
Musée Matisse
 2–7 p.m. Thursday, Saturday. Sunday 2–6 p.m. Daily June–
 October 1st 2–7 p.m.
ORANGE
Musée Lapidaire
 8–12, 2–6 p.m. (9–12, 2–5 p.m. winter).
ST JEAN CAP-FERRAT
Fondation Ephrussi-de-Rothschild
 2–6 p.m.; July and August 3–7 p.m.; closed Monday.
ST PAUL-DE-VENCE
Fondation Maeght
 10.30–12.30, 3–7 p.m. (2–6 p.m. winter).
ST REMY
Hôtel de Sade Archaeological Collection
 Visit on request
St Paul-de-Mausole
 9–12, 2–6 p.m. (2–5 p.m. winter).
ST TROPEZ
Musée de l'Annonciade
 10–12, 3–7 p.m. (2–6 p.m. winter); closed Tuesday and during
 November.
SENANQUE
Abbey
 9.30–12, 2–7 p.m. (1.30 p.m. to dusk in winter); guided visit.
SILVACANE
Abbey
 9–12, 2–7 p.m. (2–5.30 p.m. winter); closed Tuesday.
THORONET
Abbey
 10–12, 2–6 p.m. (2–4 or 5 p.m. winter); closed Tuesday.

VILLENEUVE-LES-AVIGNON
Chartreuse
9–12, 3–6.30 p.m. (2–5 p.m. winter).
Musée de l'Hospice
10–11.30 a.m., 2–6 p.m. (2–5 p.m. winter); closed Tuesday.
NIMES
All museums and monuments are open 9–12, 2–7 p.m. (2–5 p.m. winter). Combined ticket available.

INDEX

A

Aigues-Mortes, 47, 63, 69-71.
Aix-en-Provence, 14, 44, 89, 99-112
 et seq, 124, 180.
Altamira, 173.
Angers, 108, 111.
Annot, 177.
Ansouis, 74.
Antibes, 144, 146-147, 149, 158.
Apt, 12, 73, 75, 103.
Arcs, 130.
Arles, 8, 11, 39, 42, 43, 48, 49,
 51-53, 55, 60, 63, 65, 85, 125,
 171.
Arp, Jean, 165.
Aubagne, 94.
Aups, 129.
Avignon, 8, 11, 12, 19, 23-31, 53,
 161, 176, 180.

B

Bandol, 96.
Barjols, 123.
Barrême, 176.
Bar-sur-Loup, 179.
Bashkirtseff, Marie, 156.
Beaucaire, 11, 47, 61, 128.
Beaulieu, 176.
Bénézet, St, 23-24.
Bérain, 108.
Bernin, 105.
Biot, 158-161.
Bonnard, 136, 163, 167.
Bonnieux, 74.
Barmes-les-Mimosas, 134.
Boudin, 154.
Brangwyn, 19.
Brague, 156, 159, 165.

Bréa family, 8, 141, 156-157, 172.
Bréa, François, 171.
Bréa, Louis, 14, 154, 157, 160, 172,
 180.
Breughel, Peter, the Elder, 29.
Buoux, 74.
Burgundy, 11, 14.

C

Cadenet, 74.
Cagnes, 149, 158, 161, 162, 163,
 168.
Calangues, 90.
Calvet, Esprit, 27.
Camaret, 19.
Camargue, 39, 55, 56, 63-65, 67-
 68, 71, 87.
Canavesio, Jean, 173.
Cannes, 8, 142-143, 158, 176.
Cap d'Antibes, 147.
Carpentras, 12, 22-23, 79, 80.
Carro, 93.
Carry-le-Rouet, 93.
Cassis, 95-96.
Castellan, 94.
Castellane, 128, 129, 176, 180.
Cavaillon, 12, 83.
Cavalaire, 134, 135.
Cavalière, 134.
Cézanne, Paul, 7, 44, 93, 102, 104,
 111, 113-121.
Chagall, 163, 165, 167.
Chapus, Jean, 105.
Chartres, 56.
Chastel, 105, 107.
Château d'If, 90.
Châteaunoir, 120.
Chocquet, Victor, 117.
Cimiez, 156, 158.

Cocteau, Jean, 171, 174, 175.
Collobrières, 137.
Comps, 129.
Comtat Venaissin, 12, 80.
Corbusier, 92-93.
Corot, 14, 31.
Cortona, Pietro da, 91-92.
Côte d'Azur, 7, 131.

D

Daret, 107.
Daumier, 91.
Degas, 154.
Derain, 136.
Digne, 176, 180.
Draguignan, 123, 129-130, 180.
Dufy, 136, 154, 158, 167.
Durandi, Jacques, 141, 154.

E

Eisen, 107.
Entremont, 103-104.
Entrevaux, 176, 177.
Estoyes, 163.
Etang de Berre, 87, 93.
Eygalières, 44.
Eyguières, 45.
Eze, 173, 176.

F

Fabbri, 119.
Faure, Elie, 162.
Fenéon, Félix, 162.
Fontvieille, 48.
Fouguet, 14.
Fragonard, 180.
Fréjus, 137, 139-142.
Froment, Nicolas, 14, 110.

G

Gardanne, 117, 120.
Gasquet, 119.
Gemenos, 94.
Giacometti, 165.
Glanum, 37, 48.
Golfe Juan, 144, 147.
Gordes, 73, 74, 75-76.
Granet, Francis Marins, 103.
Grasse, 129, 161, 176, 177-180, 181.
Gréoux-les-Bains, 126.
Grimaud, 137.

H

Haut de Cagnes, 161, 162, 163.
Hepworth, Barbara, 165.
Hyères, 131, 133, 134.

I

Ile de France, 65.
Ile-sur-la-Sargue, 12, 80, 81-82, 83.
Iles de Lérins, 143.
Impressionists, 14, 29, 93, 115, 162.
Ingres, 103.
Istres, 94.

J

Jougues, 126.
Juan-les-Pins, 147.

K

Kandinsky, 165.
Kricke, Norbert, 165.

L

La Barben, 84.
La Brigue, 172, 173.
La Ciotat, 96.
La Colombe d'Or, 163-164.
Lacoste, 74.
La Farlède, 133.
La Fontaine de Vaucluse, 80, 82.
La Garde Freinet, 139.
La Mauresque, 175.
La Sainte Baume, 94, 133.
Lascaux, 173.
La Seyne, 97.
La Turbie, 169, 170.
Larauna, Francesco, 26-27.
Laurencin, Marie, 29.
Lawrence, D. H., 167.
Le Crau, 84, 87, 93, 124.
Léger, Fernand, 7, 159, 160, 165.
Le Grau-du-Roi, 63, 67.
Le Lavandou, 134.
Le Muy, 139.
Le Petit Roquefavour, 120.
Les Baux, 45-46, 48.
Les Collettes, 161.
Les Mesques, 173.
Les Saintes-Maries-de-la-Mer, 63, 66-69, 93, 177.
L'Estaque, 88, 93, 116, 120.
Le Tholonet, 120-121, 126, 131.
Le Thor, 80-81.
Le Thoronet (Abbey of), 123, 124.
Lorgues, 123, 124.
Lubéron, 73, 74-77, 126.
Lucéram, 154, 171, 172.
Lurçat, Jean, 54, 111-112.

M

Maillol, 137.
Maillot, 104.
Maison Carrée, 8, 60.
Malancène, 22.
Manosque, 124, 125, 126.

Mansart, 55.
Marquet, 136.
Marseilles, 8, 17, 20, 67, 87-93, 94, 99, 103, 111, 153, 178.
Martigues, 63, 93.
Matisse, 7, 9, 111, 156, 157, 158, 165, 166, 167.
Maugham, Somerset, 175.
Ménerbes, 74.
Menton, 169-171.
Meyrarques, 124.
Mignard, 103.
Mirabeau, 125.
Miro, 163, 165.
Mistral, Fréderic, 54-55.
Monet, 154.
Monte Carlo, 176.
Montmajour (Abbey of), 48-51.
Moustiers-St-Marie, 103, 126, 127-128, 129.

N

Nice, 7, 14, 94, 139, 142, 150-158, 161, 168 et seq, 177.
Nîmes, 8, 9, 47, 55, 59-61, 71-72.

O

Oppède-le-Vieux, 74.
Orange, 8, 12, 18-19, 20, 22, 23.

P

Pampelonne, 135.
Panini, 29.
Paul, Herman, 104.
Peille, 172.
Peillon, 172.
Pernes, 80.
Perugino, 91.

Peyrolles, 124.
Peyruis, 180.
Picasso, 7, 9, 121, 143, 144-146, 159, 163, 174.
Pissarro, 115, 116.
Pont-de-Gau, 66.
Pont du Gard, 61, 62.
Pont St Esprit, 18.
Provence, Marcel, 128.
Puget, Pierre, 91-92, 97, 101, 107, 124.

Q

Quarton, Enguerrand, 14, 32.

R

Rayol, 134.
Renoir, 154, 161-3.
Rey, Doctor, 42-43.
Riez, 126-127.
Robert, Hubert, 29.
Ronzen, 132.
Roquebrune, 169, 170.
Rouault, 136.
Roulin, 43.
Roussillon, 73, 74, 75.
Royers de la Valfenière, François de, 81.
Rubens, 41, 91, 105.

S

Saint-Pons, 94.
Salles, 43.
Salon, 84-85.
Sanary, 96.
School of Avignon, 8, 14, 27-30, 32, 79, 103, 154.
School of Nice, 14, 141, 154, 171, 179.

School of Paris, 29, 165.
School of Toulouse, 65.
Segonzac, 29, 136, 167.
Sénanque (Abbey of), 76-78, 79, 124.
Seurat, 29.
Signac, 136.
Silvacane (Abbey of), 77, 124.
Sisley, 29, 155.
Sisteron, 124, 182-183.
Sospel, 171, 172.
St Agnes, 171.
St Blaise, 94.
St Dalmas-de-Tende, 173.
Ste Marguerite, 143.
St Gilles, 56, 65-66.
St Honorat, 143.
St Jean Cap Ferrat, 177.
St Jean la Rivière, 174.
St Jeannet, 161, 167.
St Laurent, 168.
St Maxim, 136, 137.
St Maxime, 137.
St Maximin, 124, 126, 131-133.
St Paul, 161, 164-165, 167.
St Paul-de-Vence, 149, 163.
St Rémy, 35-37, 42, 43, 44, 45, 47, 48, 51-52, 63, 84.
St Tropez, 134.
Svetchine, André, 159.

T

Talloires, 117.
Tanaris, 97.
Tarascon, 11, 47-48, 55.
Tende, 30, 172, 173.
Tiepolo, 91, 177.
Tintoretto, 164.
Toro, 108.
Toulon, 92, 96-97, 133.
Toulouse, 11, 99.
Toulouse-Lautrec, 29.
Touraine, 14.
Touvres, 133.

Trans, 130.
Trinquetaille, 53.
Turreau (see Toro).

U

Utelle, 172.
Utrillo, 29, 136-137.
Uzès, Duchy of, 7, 14, 61, 62-63.

V

Vaison-la-Romaine, 19-22, 30.
Vallauris, 9, 143-146, 159.
Vallée des Merveilles, 9, 30.
Van Dongen, 111, 136, 167.
Van Gogh, Théo, 38-39, 51.

Van Gogh, Vincent, 7, 9, 36-44, 48, 51, 67.
Van Loo, Jean Baptiste, 110, 156.
Vaucluse, 12, 29, 75, 79, 83.
Vauvenargues, 121, 126.
Venasque, 28, 79, 80.
Vence, 149, 161, 166, 167.
Vidauban, 139.
Villefranche, 174, 175.
Villeneuve-lès-Avignon, 8, 11, 14, 23, 26, 31-33.
Vlaminck, 29, 163, 167.
Vuillard, 29.

Z

Ziem, 94, 156.
Zola, Emile, 102, 114, 115, 116.

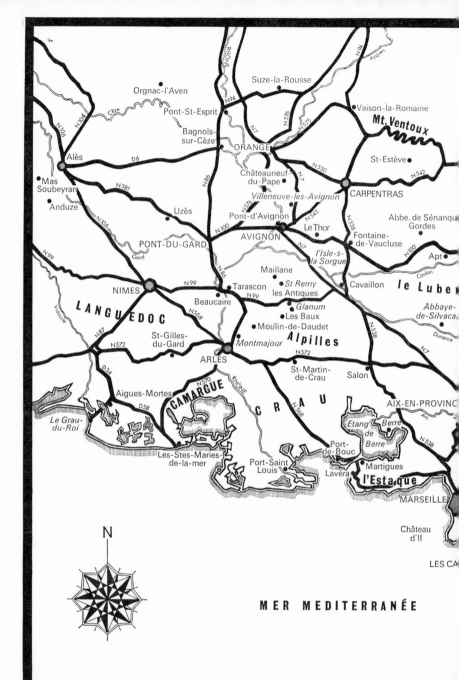